IMAGES
of America

HACKENSACK

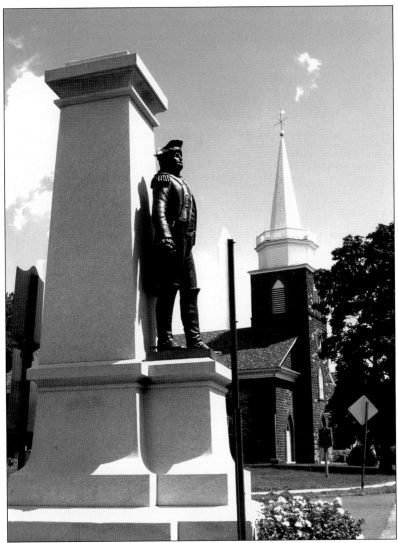

Brig. Gen. Enoch Poor was one of the Continental army's most proficient and duly respected officers. Acknowledged as one of great military vigor and intelligence, he rapidly rose through the military ranks from colonel to general with many honors. Located on "the Green," his statue stands to remind people of the important roll he played in bringing the American Revolution to a close. Despite all the military conflicts he led and survived, it was on September 8, 1780, that records lament that he died at the age of 44 of putrid fever. He is buried in the church cemetery next to the First Reformed Church. It is across from the Green, where he and George Washington, spent part of the fall of 1776.

On the cover: The Fox and Oritani Theaters on Main Street provided entertainment for several generations, from showing the latest of motion picture films, to providing Saturday morning cartoons, to hosting graduations and local talent; the likes of Hoot Gibson, a 1930s cowboy celebrity, to a cappella shows in the 1960s. The trolley tracks were no longer in use when this 1940s picture was taken. The automobile was the means of transportation and each is conveniently parked to get a good seat at the movies. For more information, please see page 51. (Courtesy of the archives of the late George Mercer Scudder, Hackensack's former historian.)

IMAGES
of America

HACKENSACK

Barbara J. Gooding, Terry E. Sellarole,
Allan Petretti, and Theresa E. Jones

ARCADIA
PUBLISHING

Published by Arcadia Publishing
Charleston SC, Chicago IL, Portsmouth NH, San Francisco CA

Printed in the United States of America

Library of Congress Catalog Card Number: 2008932685

For all general information contact Arcadia Publishing at:
Telephone 843-853-2070
Fax 843-853-0044
E-mail sales@arcadiapublishing.com
For customer service and orders:
Toll-Free 1-888-313-2665

Visit us on the Internet at www.arcadiapublishing.com

*To my entire family and endearing friends that made growing up
in Hackensack filled with cherished memories —B. J. G.*

*In memory of George Sellarole Sr. (Hackensack High School
class of 1915), who taught me to appreciate my Italian heritage while
being a proud American from Hackensack —T. E. S.*

*In memory of my uncle, Dan Petretti, who helped build Hackensack's
Main Street and dedicated his life to family and community —A. P.*

*For Dave Seddon—teacher, mentor, and friend. You've made more of a
difference than you could ever imagine. (Go Red Sox!) —T. E. J.*

CONTENTS

ACKNOWLEDGMENTS

First and foremost we need to thank the late George Mercer Scudder, Hackensack's former historian, for requesting his archives be given to Barbara J. Gooding to make use as she desired. When approached to do this book, *Hackensack*, clearly we recognized that the majority of the enclosed works would not have been possible without his thoughtfulness and generosity. We will forever be grateful to Bob Kutik of Womrath's Bookstore, once a famous Hackensack store now located in Tenafly, New Jersey, for his introduction to Arcadia Publishing and encouragement to produce this book. Our endless appreciation to our editor, Erin Rocha. She is an exceptional person who throughout this undertaking was a pleasure to work with in taking this project to its completion.

To fulfill this book it would not be possible without the efforts of several longtime Hackensack residents and business owners who supported our efforts with images, facts, and insight that literally reinforced the archival contents that initiated this beloved endeavor. Our many thanks are extended to the James D. Kozak family, the Nicholas J. Guerra family, Lenore and Michael Devine, Barbara Schoonmaker, Rannie Petretti, Virginia Long, Joseph, Sandra and Joseph Romano Jr., Evelyn M. Sellarole, George and Peggy Liosi, and Albert Cappellini.

Lastly, we need to thank our families and friends whose constant encouragement, support, and forbearance enabled that initial kind gesture from George Mercer Scudder of donating such historical imagery and documentation to make this book possible.

INTRODUCTION

And I will wait for you, As long as I need to,
And if you ever get back to Hackensack, I'll be here for you.
—"Hackensack" by Fountains of Wayne, from the album titled *Welcome Interstate Managers*

Hackensack's historical significance starts with the arrival of European colonists in 1664, their encounter with the Lenni-Lenape Indians and the one tribe in particular known as the Achkenheshacky people, hence termed the Hackensack Indians, and in time, the name of the city. There are several monuments, documented stories, and essays on the role that Hackensack played in winning the Revolutionary War as Hackensack was a strategic landmark close to the Hackensack River, as well as the Hudson River. At the dawn of the 19th century, Hackensack was the draw for those wishing for a healthy lifestyle of fresh air emanating from all the magnificent trees as well as the offerings a river can give to business and recreation. The wealthy came in droves. Grand hotels, homes, a golf club, and a major field club ensued, along with many other amenities. Following World War II through the 1960s, Hackensack was a bustling area of commerce, which included an abundance of shopping for all in the northern New Jersey area until the onset of shopping malls and plazas. Today a new economic development is in process and promises to bring the lure once again to Hackensack.

It was in 1693 that a large landmass that went all the way up to today's towns known as West Milford and Ringwood and down to Kearney was named New Barbadoes Township. That same year the village of Hackensack was formed within the township's borders. Later in 1709, Hackensack became the county seat of Bergen while other portions of New Barbadoes became other municipalities. It was in November 1921 that Hackensack was incorporated and officially named the City of Hackensack and in essence New Barbadoes Township, in name, no longer existed.

The city size today stands at 4.3 square miles, seven miles west of Manhattan, 12 miles south of New York's Rockland County, and situated near the center of Bergen County. The Hackensack River runs along its east border and has played a very big and integral part in the city's development. For several centuries, it served as a central waterway for trade with the Lenni-Lenape Indians and the Dutch and English settlers. For business and factory owners of the 19th and 20th centuries, pottery and brickmaking were two prosperous enterprises made possible due to its riverbed being a source of rich clay. The river, although continuing to play a major role in developing Hackensack's history, is best recalled in photographs and reminiscent dialog in memories of the river as a source of sport, recreational outings, and timeless relaxation at the

later part of the 19th century and the first quarter of the 20th century. Boathouse slips were lined with small boats ready to navigate up and down the river and swimmers could be found diving from riverbanks on a summer's afternoon. Both activities would share the waterways with the commercial enterprises that continued up and down the Hackensack River.

How fast the city evolved in just a few short centuries truly signifies why Hackensack is termed "a city in motion," and is a reflective statement of the city's past and a symbolic message for its future development. It is documented that in the early 19th century, with all the city's offerings, everything seemed to concentrate in Hackensack. Inns and taverns became a necessity as riverboat trade increased. They became not only a place to gather for drinks, food, and socializing, but these establishments were also the place for town meetings and elections. Some inns were enlarged to the size required by the state to be qualified and licensed as a stagecoach stop and were mandated to save rooms for travelers and have provisions for horses. Many innkeepers were licensed and considered a member of the town council and set the guidelines for enforcing its laws and for cultivating the city's future.

With the renowned popularity of Hackensack, the population was growing and the comforts we take so readily today needed to be established. Town officials and conscientious citizens joined to make dusty dirt roads become cobblestone or gravel, and in 1889, provided the major roads with trolley tracks for commuting within the city and to those towns surrounding it. The first energy company to come to this area was the Hackensack Gas Company in 1861, yet gas lanterns that lit up the streets were costly as each needed to be individually lit every night and extinguished the next morning. It would take a few more years, but soon electricity threaded its way throughout Hackensack. The first telephone in Hackensack dates back to 1882 and soon after the first switchboard with a capacity of 25 lines. Backyard wells and cisterns could not be continued to be relied on and fire departments could not fight fires unless they had adequate water supply. Charles H. Voorhees and G. N. Zingsem, both influential and respected men obtained a charter for establishing a water company. On July 11, 1873, they started construction work on a waterworks system. Soon, on Zabriskie's large farm in Hackensack's Cherry Hill section, water pipes were laid throughout the streets of Hackensack from Essex Street to the northern boundaries. On October 21, 1874, the fountain on "the Green" ceremoniously acknowledged the accomplishment of flowing water. By 1903, gas, electric, and transportation were in good shape and together were founded as the Public Service Corporation. Hackensack had come of modern age.

This grand city continues to grow and define itself with new structures, businesses, houses of worship, schools, and the diversity of its residents. With its five wards, each has a distinct history that when combined is a true example of America's melting pot. Its name can be found in the works of songwriters and filmmakers. Comedians, Olympic winners, actors, and astronauts can distinctly say their time in Hackensack helped characterize their success.

For those of us who reside in Hackensack or in part worked, lived, or vacationed in this city, it is immensely important to acknowledge that there will always be more facts to be printed and stories to be told. It is certain for any reader that they will find an attachment to some portion of this book. Its centuries of growth and elements of interest will educate many on this city's grand past and spark countless memories and images. They will come to realize that Hackensack has and can make any person's or businesses' dreams of success, here or elsewhere, a reality just by knowing they had at one time or another, picked the best place to live.

One

THE CITY DEVELOPS

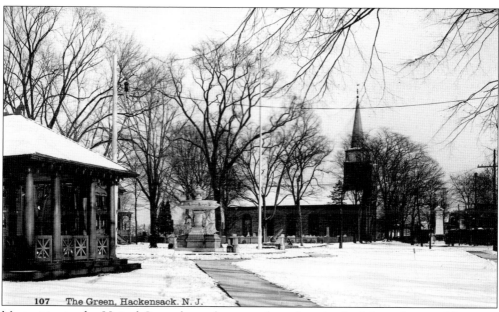

107 The Green, Hackensack. N. J.

Most cities in the United States have that one place that simply defines them and becomes the common ground for the entire community. In Hackensack, it is "the Green." This is the most historically defined piece of property in the area, and a spot where Revolutionary War soldiers camped, including Gen. George Washington's Continental army and Brig. Gen. Enoch Poor. Shown above is the Green around 1910 in winter, blanketed in snow. Next to the gazebo can be seen the fountain, which was installed in 1874, made possible by then recently installed water lines.

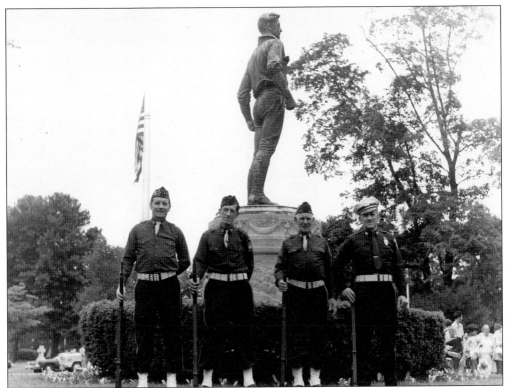

Over the years, the Green was the centerpiece of most city celebrations and historic events. Shown above is a group of veterans standing in front of the World's War Memorial, which honors the men of Hackensack who fought for the country.

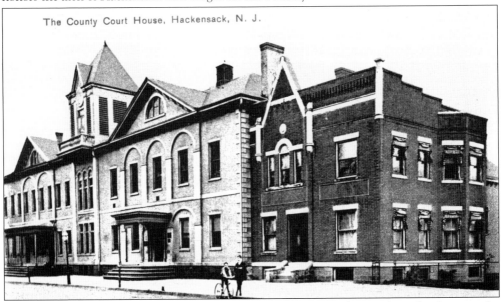

The County Court House, Hackensack, N. J.

Pictured in 1895 is the second Bergen County Court House located across from the Green at the southern end of Main Street. This updated and enlarged building replaced the first courthouse, built in 1799 located on the same site.

The Bergen County Court House is located at the southern end of Main Street. Originally erected in 1799, it was demolished in 1873 only to be rebuilt and enlarged in 1895. It is modeled after the United States Capitol with a female figure adorning its copper dome representing the principle of justice and so named *Enlightenment Giving Power.*

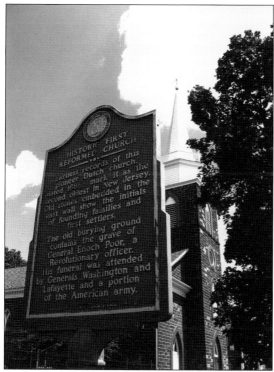

The First Reformed Protestant (Dutch) Church of Hackensack has been coined by many over the centuries as the "Old Church on the Green." Built in 1696 and then rebuilt in 1791, it is Bergen County's oldest church and the second oldest in New Jersey.

Grand juries today are nearly unknown outside of the United States. A grand jury is meant to be part of the system of checks and balances, which could prevent an unwarranted case from going to trial. So may have been the occasion when this picture was taken in front of the sheriff's office.

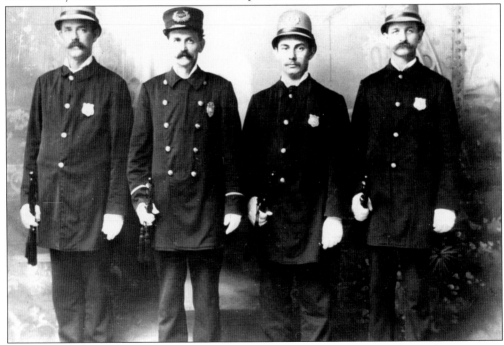

The concerns and safety of its citizens have been the highest priorities for Hackensack's governing body. The Hackensack Improvement Commission elected its first board of commissioners on April 1, 1868. The commission's job was to oversee public service, including streets and sidewalks, the water company, the Hackensack River, board of health, and, of course, the police and fire departments. The Hackensack Police Department was organized in 1896 and consisted of these four officers, shown from left to right, Mike Breen, Cornelius Van Blarcom, Al Schtleben, and Martin O'Shea. The Hackensack Fire Department started as a volunteer organization. As Hackensack began to grow in the 1800s, fires were an everyday problem. On April 6, 1871, the commission approved the establishment of the city's first official fire department.

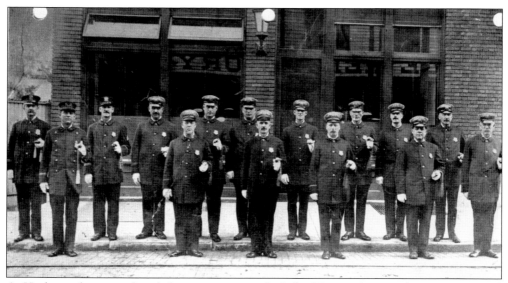

As Hackensack grew and settled into its status as the hub of Bergen County, the increasing need to enforce the laws of the growing city mandated the need to expand its police department. Shown above is the newly expanded department around 1916. Jacob Dunn was the chief at the time.

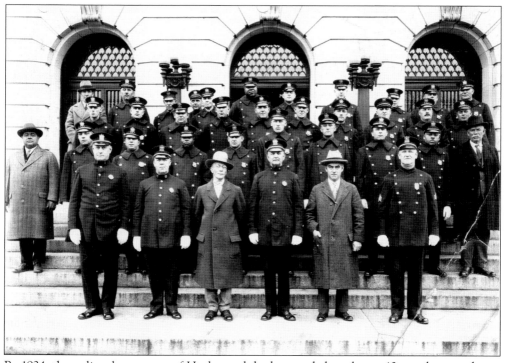

By 1924, the police department of Hackensack had expanded to almost 40 members, as shown here on the steps of the Bergen County Court House. The police commissioner and Chief of Police M. J. O'Shea are standing front row, center.

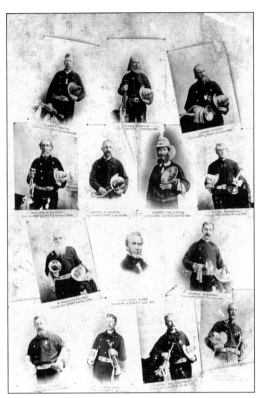

On May 18, 1892, the Exempt Firemen's Association issued this souvenir photograph of the retired chiefs and assistant chiefs of the fire department from 1871 to 1891. Included is the very first chief, John Ward, who was elected in 1871 but passed away in 1872.

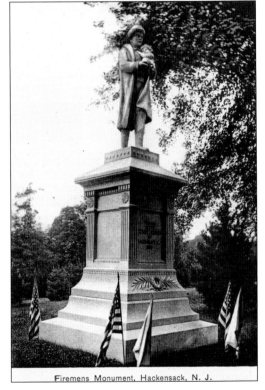

Firemens Monument, Hackensack, N. J.

In 1907 the Exempt Firemen of Hackensack erected a monument to honor all the brave men who had served the community. Today this monument can be found in the Hackensack Cemetery.

14

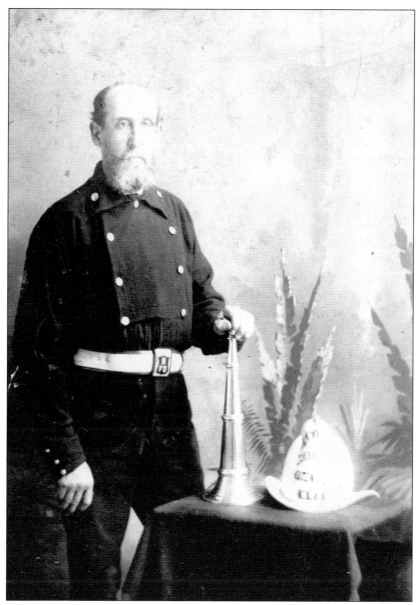

Pictured above is Justice Millard W. Heath, who was elected chief of the Hackensack Fire Department in 1886 and retired three years later. He also served as the inspector of the Electric Fire and Alarm System. Justice Heath was one of Hackensack's most honored and best known citizens. Born in South Carolina in 1843, he served through the Civil War with the Confederate army and was twice wounded in the leg, which rendered him permanently lame. Although a druggist by profession and practicing as a dentist, he was best known as "Doc" or "Judge" having been a justice of the peace for 15 years with his office on the corner of Main and Bergen Streets. During his official career, he sent more persons to the Hackensack jail and had the record for marrying more couples, surpassing all the other justices in Bergen County. Heath was married to Sarah E. Gamewell, who was a daughter of John N. Gamewell, inventor of the fire alarm system bearing his name that today is recognized and utilized all over the United States. This photograph was taken by S. G. Van Derek of the Bijou Studio of Art on State Street.

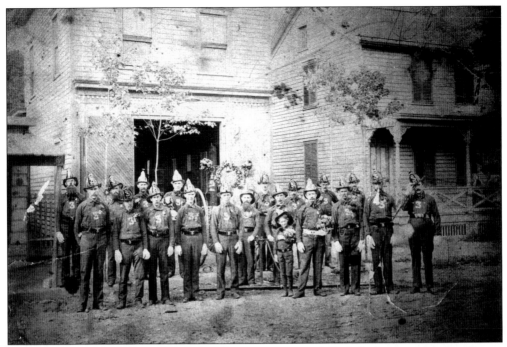

The *c.* 1890s Hudson Hose Company No. 3 is seen at its newly built firehouse on Hudson Street.

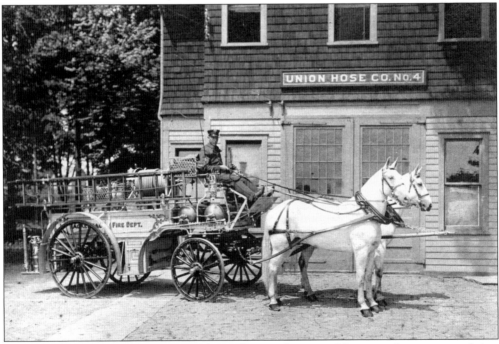

The Union Hose Company No. 4 is shown here with its sparkling-new fire apparatus being pulled by the team of Dolly and Daisy. By 1950, Fire Company No. 5 was created and located on Summit Avenue to cover the Heights or Hill section of Hackensack. In 1907, the Exempt Firemen's Association of Hackensack erected a monument to honor all the brave men who had served the community, which today can be found in the Hackensack Cemetery.

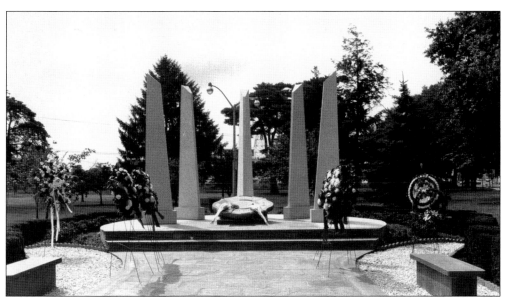

Over the years, Hackensack has had its share of spectacular and destructive fires, including the Fairmount Hotel on Summit Avenue, the armory, the Second Reform Church, State Street School in 1910, the Borden Company, and the Comfort Coal Lumber Company. Nothing was more devastating than the Ford dealership fire on Friday, July 1, 1988, in which five firefighters lost their lives.

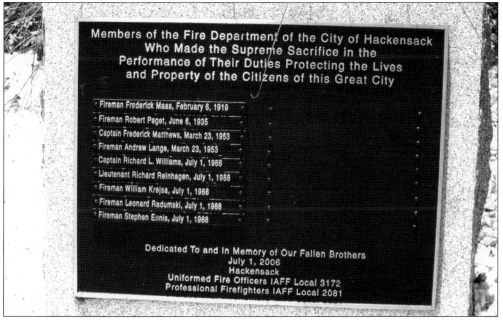

The monument pictured above was erected in 2004 and its plaque reads "On Friday, July 1, 1988 five members of the Fire Department of the City of Hackensack made the supreme sacrifice in the performance of their duties while operating at fire alarm #1177. These pylons are dedicated to their memory." The citizens of Hackensack will be forever grateful to these five, as well as all firefighters who serve and protect the community. The Fallen Firefighter's Monument lists members of the fire department of the city of Hackensack who lost their lives in the line of duty.

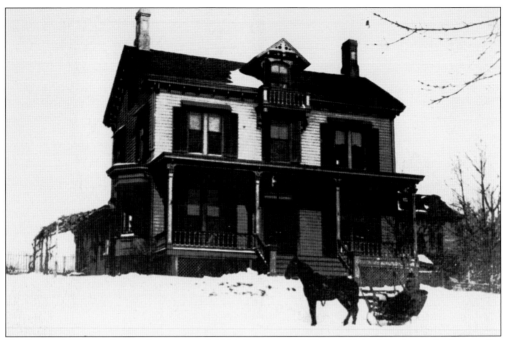

Hackensack Hospital, seen here around 1890, began in 1888 as a 12-bed facility, which was the first hospital in Bergen County. The horse-drawn sled stationed in front was an early precursor to today's ambulance service.

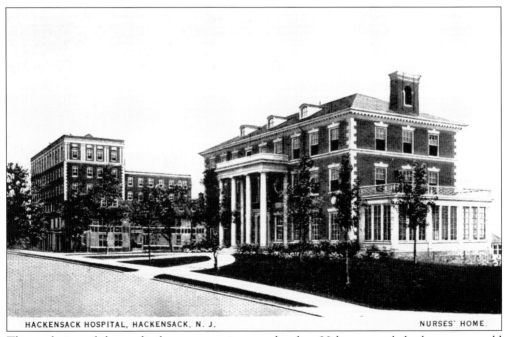

HACKENSACK HOSPITAL, HACKENSACK, N. J. NURSES' HOME.

The evolution of the medical center continues today, but 20th-century baby boomers would remember this look of Hackensack Hospital back in the 1950s. The nurses quarters were located to the right.

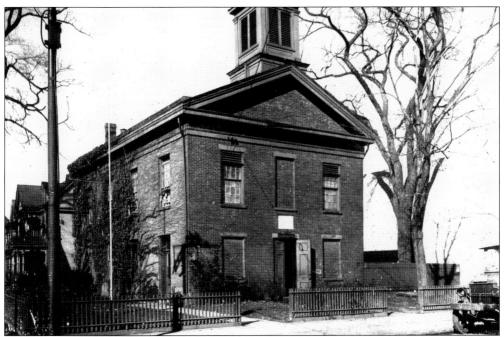

Located on the corner of Main and Warren Streets, the Washington Academy was founded in 1769. Originally a private school for boys, it was renamed the Washington Institute in 1847, and later became Hackensack's first public school. By 1878, the building was no longer being used as a school. It later housed the Hackensack Public Library and reading room on the second floor until 1901. The building was torn down in 1926.

On Saturday afternoon, May 11, 1878, the cornerstone was ceremoniously placed, commemorating Hackensack's first public school.

SCHOOL DISTRICT No. 32.

The citizens of the county, and especially those of School District No. 32, Village of Hackensack, are invited to participate in the services connected with the

LAYING OF THE CORNER-STONE

OF THE

New School Building,

ON

SATURDAY AFTERNOON, MAY 11, 1878,

AT THREE O'CLOCK, ON WHICH OCCASION

Hon. Wm. Walter Phelps
and Hon. A. A. Hardenbergh

Will be present and address the audience.

It is hoped that the citizens will generally attend these exercises, and thereby show their appreciation of the increased school facilities of Hackensack.

Printed at the Democrat Office, Hackensack.

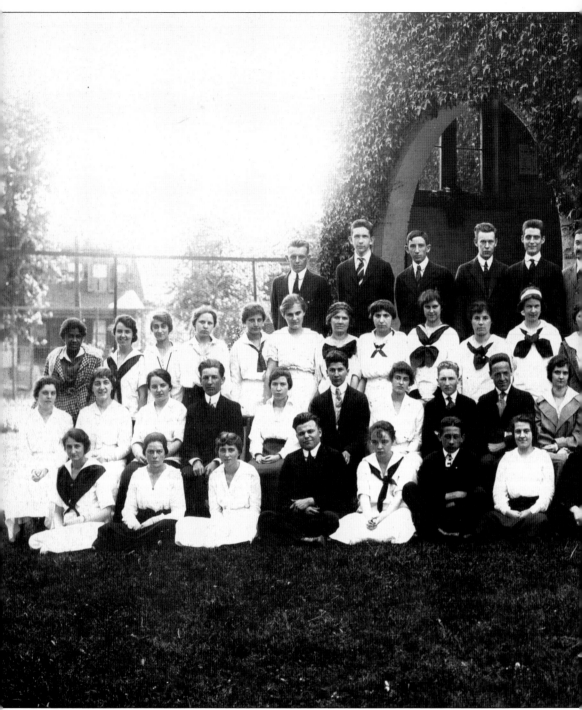

The Hackensack High School class of 1916 was the second to last to graduate from its then location on the southwest corner of First and High Streets. Built at a cost of $12,000, the four-and-a-half-story building with no basement was constructed entirely of brick, and the floors were solid pine. Students began attending in 1898. Being the only four-year high school in the area, it attracted students from towns outside Bergen County. Students from other towns were

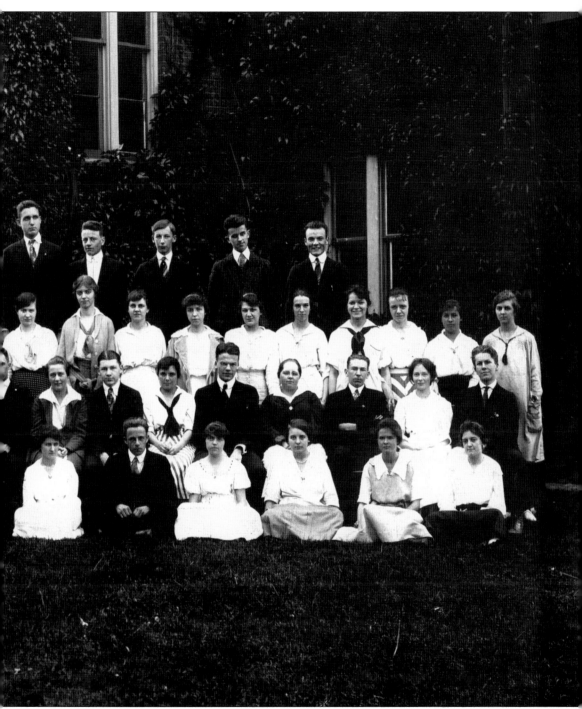

required to pay a tuition of $10 for each course the child took; quite a hefty fee for 1898. Records show that 81 towns sent students to Hackensack High School during its 20-year existence. On December 21, 1916, the cornerstone of the new building was laid with all the proper ceremonies. In March 1918, students from the old high school entered the new high school located at 135 First Street.

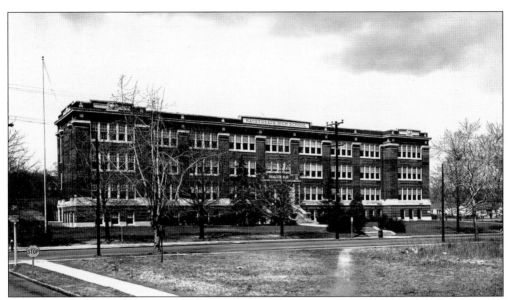

Except for the stone marquee above the front entrance that proclaims this school to be none other than Hackensack High School, little of the building shown here is recognizable as being the same edifice. During the 1960s, the school underwent a series of renovations and additions, including a two-story bridge that connected this building to the former Beech Street School across the street, which had not even been constructed at the time this photograph was taken in 1949. In the process, the main entrance was converted to the western terminating point for the bridge, which houses classrooms on the lower level and the school's library media center on the upper level.

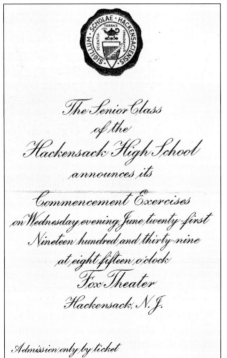

The Senior Class
of the
Hackensack High School
announces its

Commencement Exercises
on Wednesday evening June twenty-first
Nineteen hundred and thirty-nine
at eight fifteen o'clock
Fox Theater
Hackensack, N.J.

Admission only by ticket

In order to accommodate all the parents and invited guests at the 1939 Hackensack High School graduation, the Fox Theater on Main Street was selected as it was one of the few places deemed large enough. Its grand stage and abundant seating on the main floor and balcony made it the perfect location.

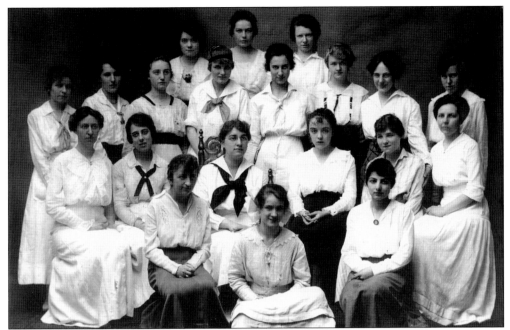

Being part of a Hackensack High School sorority like Sigma Sigma, pictured in this 1916 photograph, or a fraternity such as Delta Sigma Nu was a means for teens to be joined together by similar interests and common fellowship. Many who were invited to join these social clubs were bound for college after high school but it was never a prerequisite for membership. Pledging to be loyal to each other and conforming to their unique code of ethics was all that was needed to enjoy the camaraderie that would ensue during high school years and those thereafter.

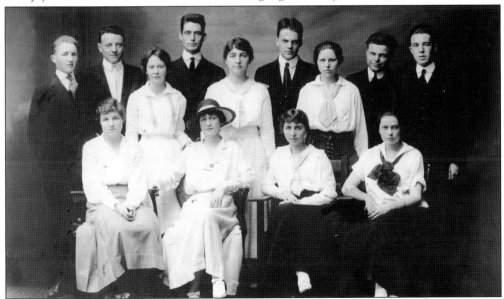

Shown above is the cast of the 1916 Hackensack High School senior class play, *A Scrap of Paper*. Be it original pieces of work or a rendition of a famous Broadway play or novel, students would practice for months memorizing lines and music to showcase their talents to parents, teachers, and friends for the yearly production of the high school play.

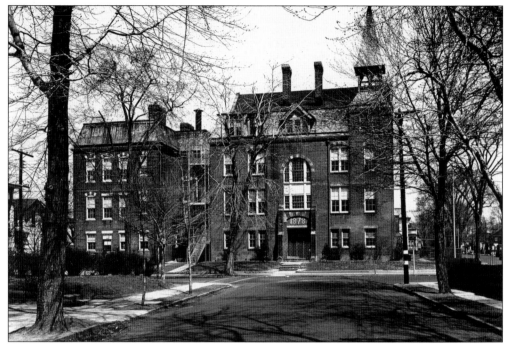

The Union Street School had the distinction of being the first building erected for the purpose of providing a public education to the children of the village of Hackensack in 1878. In actuality, the school replaced an existing structure—the formerly private Washington Institute—which had become too small to accommodate a growing populace that was beginning to value the ideals of education for all. Located on the corner of Main and Warren Streets, the Union Street School served the children of the city from 1878 until 1950, when a severe storm caused the roof to be torn from the school and the large chimneys to crash into the school's basement.

Seated in his office is one of the Union Street School's principals, C. M. Dalrymple, who served in this position between 1905 and 1918.

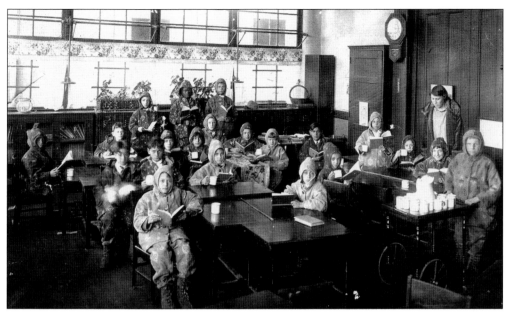

Education has always been a main part of Hackensack's city equation. Beginning in the 1920s, health and physical education became the dominating subjects in public schools throughout the state. To meet state approval, every school had to provide a suitable gymnasium and an outside playing field and a fully equipped medical room. Maintaining good health and preventing the spread of colds and germs was essential to every student's well-being. In the 1930s, Broadway School enacted an experiment that was termed the "open air classroom." Class was conducted as normal but with the windows wide open to allow in the fresh air as is depicted in this photograph on a cold winter's day. Students take a break to sip on a warm beverage for this photograph taken at 10:15 a.m., before returning to their lessons.

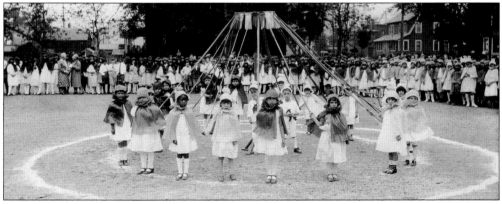

In earlier days, youngsters sought to entertain themselves by playing outdoors much more frequently than the children of today. They played games like hop scotch, marbles, and stoop ball, and they knew what it was to dance around a maypole. This group of Broadway School girls stands ready to begin the well-choreographed movements that will weave the ribbons at the top of the pole into a colorful design around the pole in celebration of May Day 1925.

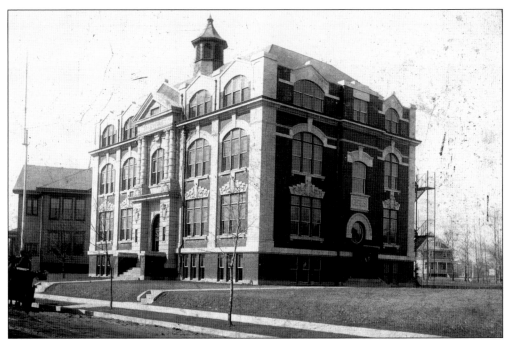

Built in 1890, Fairmount School was originally called Cherry Hill School. The new Fairmount School shown here was built in 1909. This larger school solved the overcrowding problem from the booming population growth of the Fairmount area of Hackensack. Several more renovations were made to this building in 1916–1929 and again in 1932.

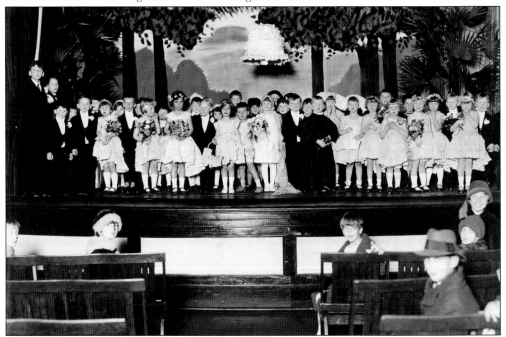

Fairmount School students have performed in many stage productions over the years. This 1927 photograph shows kindergarten children performing in a Tom Thumb wedding. The young performers portrayed their roles as the groom and bride, their attendants, and invited guests.

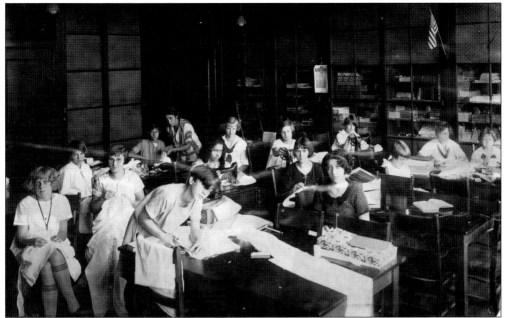

Records from the Hackensack Board of Education meeting minutes show that "sewing classes were inaugurated in all schools" in February 1896, as the thrust for providing students with a curriculum in "manual training" became popular across the nation. Students in this early-1900s sewing class learned valuable life skills as their teacher looks on from her desk. The lone boy in the photograph, shown cutting fabric for his project, certainly had ample opportunities to meet members of the opposite sex.

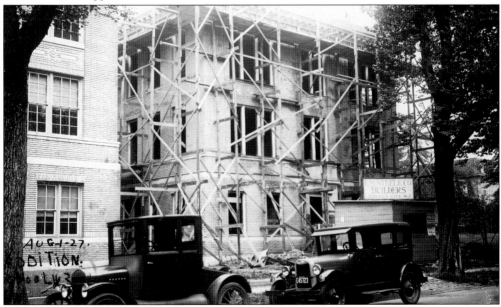

Progress was swift during construction of the new board of education offices in the summer of 1927. The three-story brick addition to the State Street School was designed and built to so closely match the original building, it is difficult to discern where one building ends and the other begins. This photograph was taken on August 1, 1927.

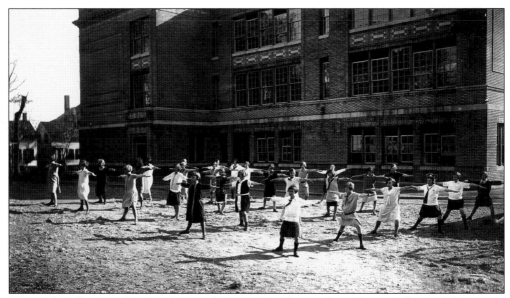

When this photograph was taken in June 1927, sights such as the one depicted here were commonplace in school yards across America. These State Street School girls—segregated from their male counterparts for physical activities—are shown participating in the calisthenics deemed to be a necessary part of a child's school day. The site on which they are working out would later become the site on which the board of education offices would be erected as an addition to the school itself.

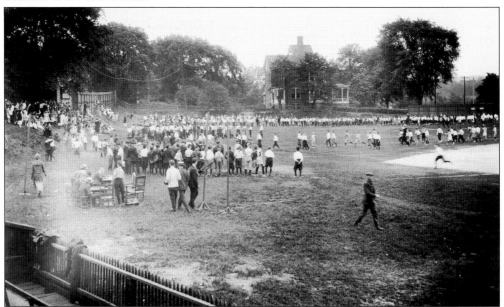

For many elementary school–age children, one of the most anticipated events of the school year is the annual field day. Tug-of-war matches, foot races, and other games that allow youngsters to show off their athletic prowess in front of the entire student body make for an exciting break from the normal academic routine. In 1925, boys in grades seven and eight gathered at the Oritani Field Club for their yearly contests, as shown in the photograph above. It appears the only females allowed on the field were the spectators on the hill (left).

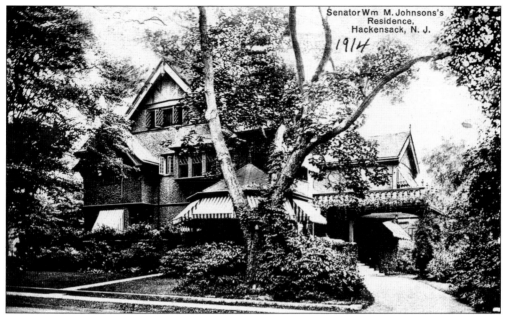

Shown above is the very beautiful home of Sen. William Johnson in the early 1900s. It was located on the northeast corner of Main and Anderson Streets where Sears is located today. His house faced Anderson Street, and his property extended from Main Street to the Hackensack River. At the time, River Street did not exist.

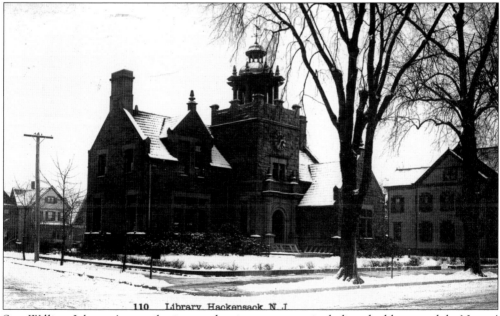

Sen. William Johnson's contributions to the city were many, including the library and the Nurses' Home at the hospital, as well as his contributions to the Oritani Field Club. The Hackensack Library Association was formed in 1871 and met in the Washington Institute while various groups maintained the library in Hackensack. It was not until Senator Johnson bought a piece of property from the Berdan family on the corner of Main and Camden Streets that he constructed the existing library. He furnished it with books and donated it to the citizens of Hackensack.

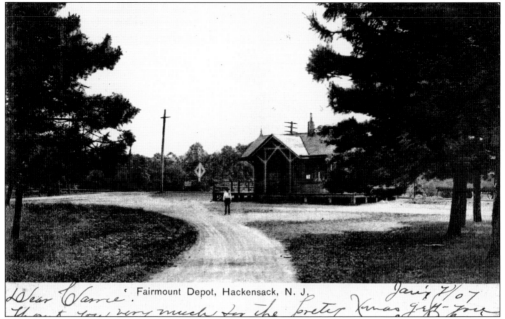

Fairmount station, Hackensack's northernmost train stop, is pictured above in 1907. Today the station looks much the same but is occupied by a gift shop.

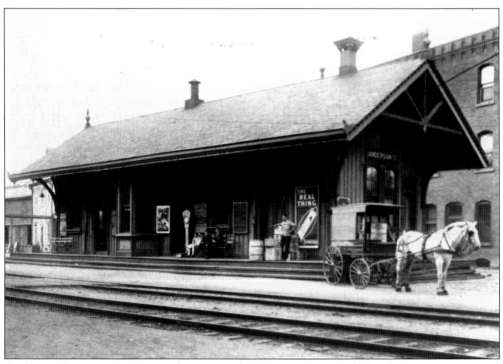

Anderson Street station, shown above around 1907, was the typical New Jersey train station of the day. It still is a major stop for today's commuters.

30

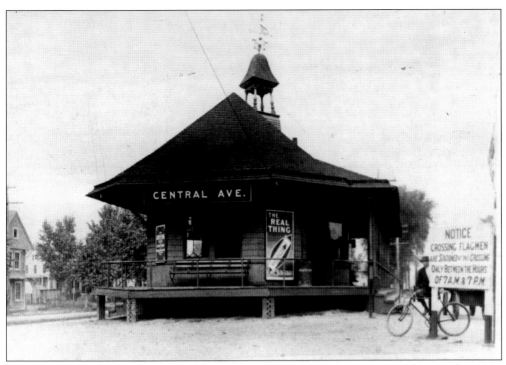

The Central Avenue station, shown above around 1907, is no longer there and Central Avenue is no longer a stop for train service.

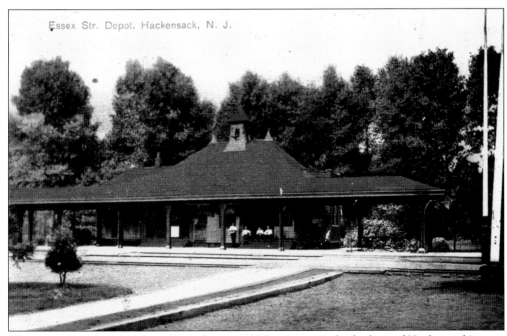

The Essex Street train depot, shown here in 1908, was certainly the best of Hackensack's train depots. Close to businesses and manufacturing, this was an important stop in Hackensack.

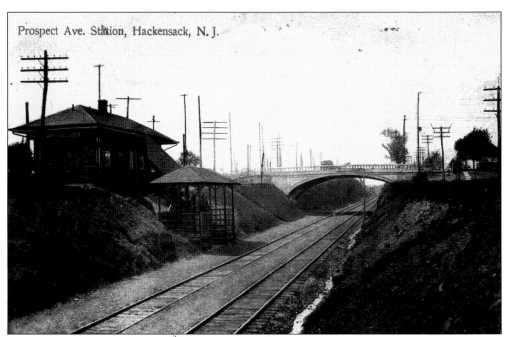

The Prospect Avenue station, shown here around 1909, served the city in the Heights or Hill section of Hackensack.

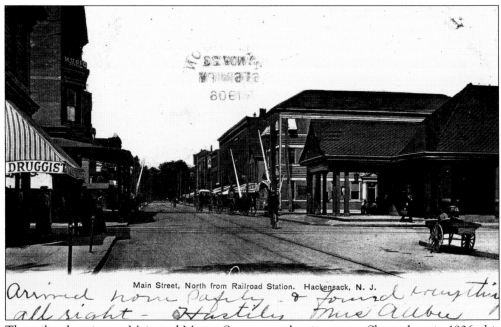

The railroad station on Main and Mercer Streets was the city center. Shown here in 1906, this is what first-time visitors to Hackensack usually saw; a busy Main Street and a bustling city, with well-groomed neighborhoods surrounding it.

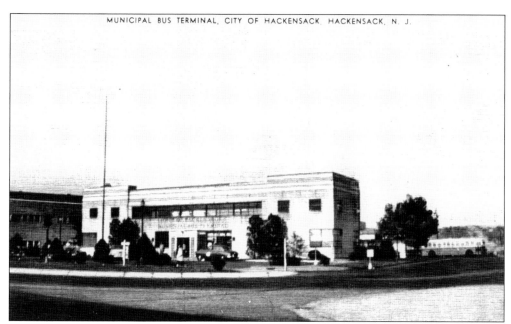

The municipal bus terminal on River Street in Hackensack was a state-of-the-art building. It is shown here in the 1950s. Comfortably heated with a cafeteria, it was a landmark in its day. Nowadays, it has been replaced by another landmark, the Heritage Diner. Hackensack now is the hub of Bergen County, as it is easily accessible through many modes of transportation.

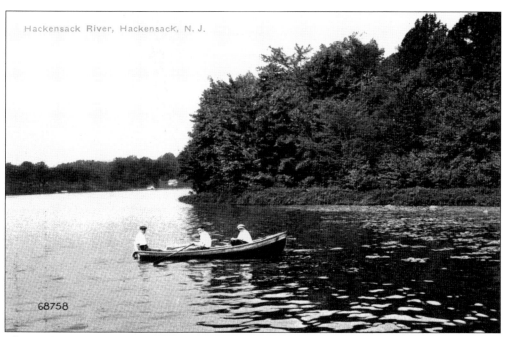

The Hackensack River offered an easy means of escaping the bustle of a growing city back in the early 20th century. Be it a lunchtime break, an after-work retreat, or a summer weekend outing, the river's wide and winding path, lined with trees and other vegetation, offered the luxury of seeming to be in the country in a small boat.

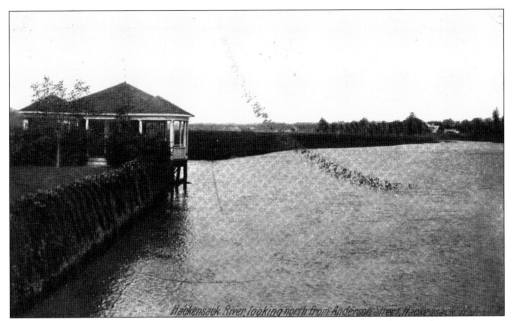

This view of the Hackensack River looking north from Anderson Street depicts the river at one of its widest points, allowing swimmers, boaters, and commercial enterprises to share its space.

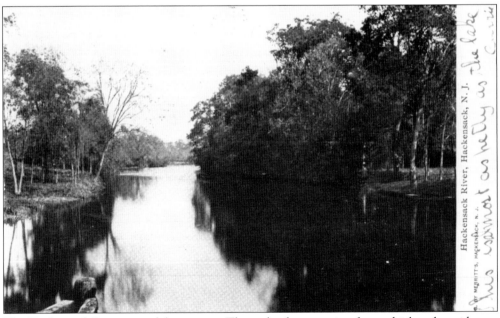

The Hackensack River is a tidal waterway. The rush of water going from a high to low tide can be almost thunderous as it makes its way from New York State to Newark Bay. There is that time in between, however, when the river presents its peaceful side as if taking a rest before the cycle begins again, as depicted here in 1907.

Two

MERCHANTS
AND SHOPKEEPERS

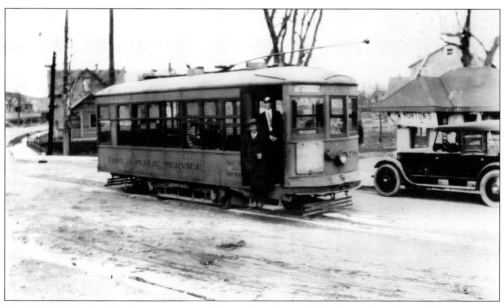

The Public Service Company ran a trolley service through Hackensack. The trolley ran north and south from Zabriskie's Pond down Main Street and Hudson Street, through Little Ferry, and on to Weehawken. This easy and affordable means of transportation allowed citizens from all over Hackensack to travel about town and shop at the many retail stores popping up on Front Street, which later would be renamed Main Street. Theaters soon followed and restaurants were established along the way. By the mid-20th century, Hackensack's Main Street had become the premier thoroughfare in northern New Jersey.

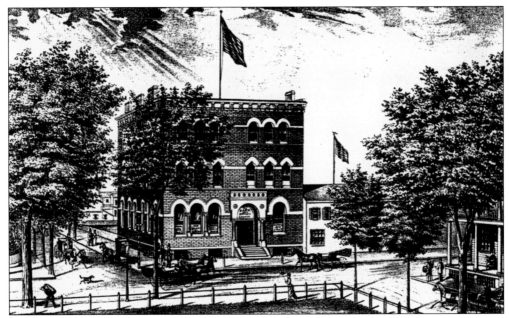

One of the most noted banks in Hackensack's early years was the Bank of Bergen County, shown here in 1898. This bank helped newly formed businesses with financial services for many years. Located on the corner of Main and Morris Streets (which no longer exists), the building is currently known as the Breslin Building. Its convenient location to the Bergen County Court House makes it an ideal location for the law offices housed within.

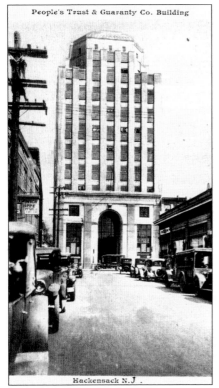

A Hackensack landmark and monument to banking was the People's Trust and Guaranty Company at 210 Main Street. The view shown here, as seen from Banta Place, is from the 1930s, but little has changed during the ensuing seven decades, with the notable exception being the name of the bank within. At the time of its construction, in 1926, this was the tallest building in Bergen County. Sadly, severe water damage has caused the building's recent closure, and its future hangs in the balance.

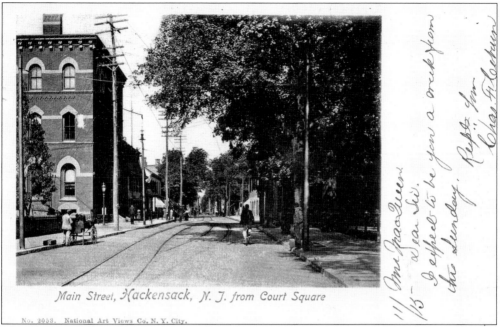

Main Street, Hackensack, N. J. from Court Square

No. 2053. National Art Views Co. N. Y. City.

This is a view of Main Street looking north from its most southern end near the courthouse and the Green. The trolley and horse-drawn buggy were the means of transportation for shopping or conducting business. The Bank of Bergen County, also known as the Breslin Building, is on the left.

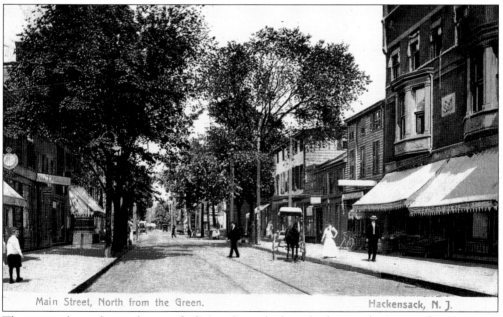

Main Street, North from the Green. Hackensack, N. J.

This image shows the southern end of Main Street looking further north. Any product or service was available from the merchants that lined the numerous stretch of blocks that Main Street occupied. The fish market is located on the right side and the place where today's General Poor's Tavern stands is situated on the left side of the street.

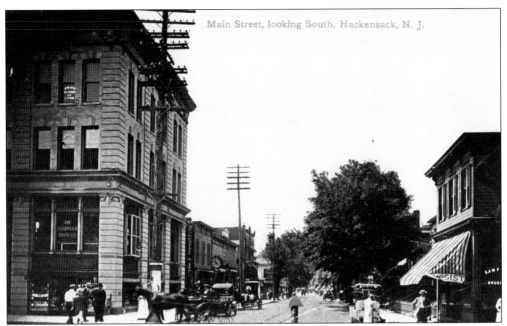

On December 23, 1899, the Hackensack Trust Company opened on the corner of Main and Mercer Streets. On March 4, 1922, it merged with the Hackensack National Bank making it one of several prosperous financial institutions that lined Main Street.

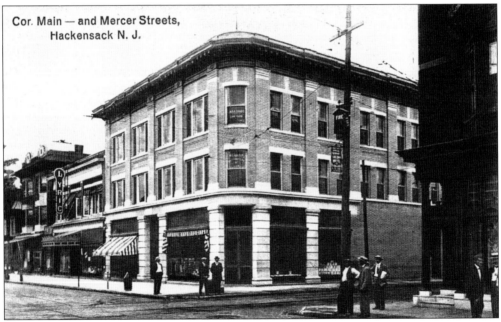

Cor. Main — and Mercer Streets, Hackensack N. J.

The intersection of Main and Mercer Streets served as a popular meeting place for many years. In addition to its central location, the intersection was the home of the Lyric Theater, which was one of the developing city's earliest venues for watching the latest in live entertainment or a silent film. A ready audience could be found in tired shoppers who needed a place to rest after a long day on their feet, so theaters were built to complement the shopping experience.

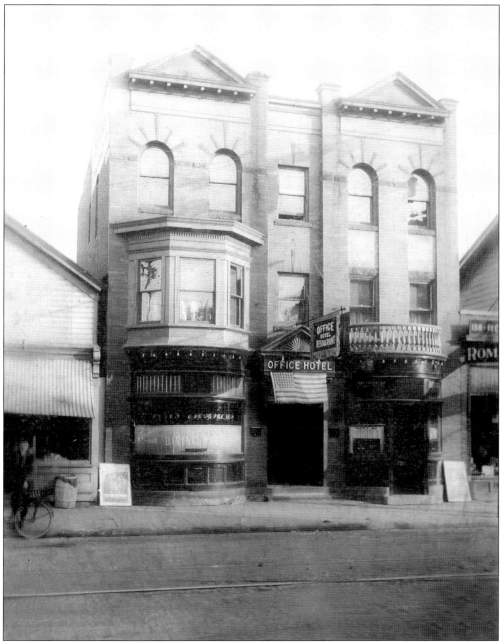

Shown here is the Office Hotel and Restaurant around 1912, located at 160 Main Street, between Mercer and Demarest Place. The Office Hotel boasted first-class accommodations and fine dining. While many other hotels both small and large graced Hackensack with friendly accommodations over the years, probably none were so important and widely recognized as the Fairmount Hotel. The Fairmount was a sprawling hotel that extended from Summit Avenue to Spring Valley Avenue, to Fairmount Avenue, and as far west as Coles Brook. The Fairmount, which stood for close to 25 years, burned down in the late 19th century. Although it had been a famous attraction for residents, visitors, and tourists alike, unfortunately very few images of this beautiful hotel exist.

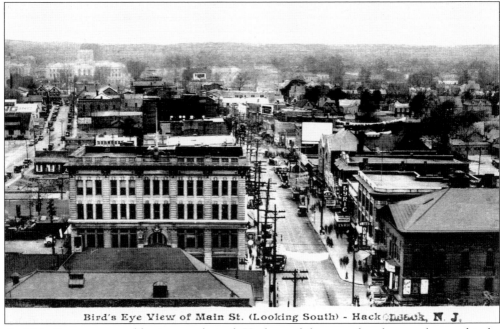

Bird's Eye View of Main St. (Looking South) - Hackensack, N. J.

As Main Street grew and businesses thrived, Hackensack became the place to shop and to be seen. The latest fashions and the trendiest of goods could be found along this amazing stretch of stores. This 1920s bird's-eye view of Main Street, looking south, gives one an overview of the city's rapidly growing business district.

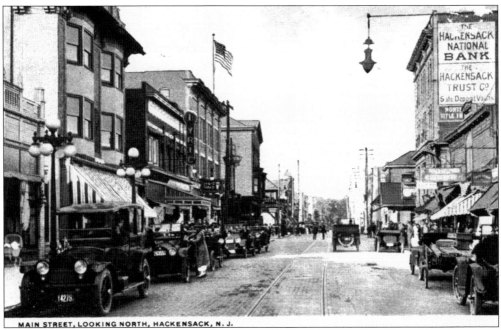

MAIN STREET, LOOKING NORTH, HACKENSACK, N. J.

By the 1920s, horse and buggies were then nearly all but replaced by motorcars, which shoppers lined up along Main Street. At the time, there were no parking meters to limit the amount of time spent shopping or traffic lights to delay going from one end of Main Street to the other.

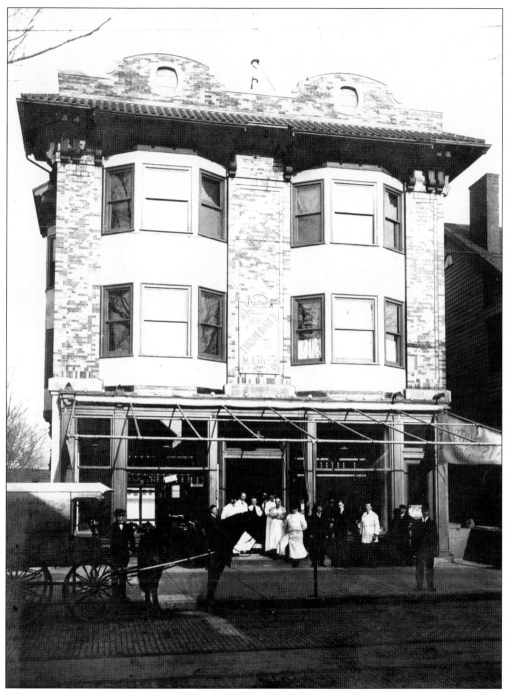

The Consolidated Market was located at 153 Main Street and was unique because of its distinction as an early precursor to today's supermarkets. Built at a time when individuals were beginning to move away from growing or producing the majority of their own food, the market provided customers with a selection of meats, breads, canned goods, and produce, all under one roof. This photograph, taken around 1895, shows the market's full staff, including Johnson the deliveryman.

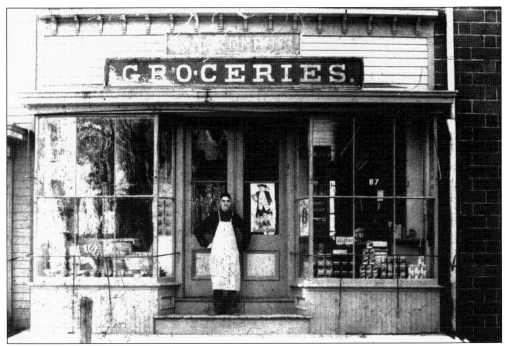

A young worker stands outside this grocery store at 67 Main Street, around 1915, for a brief moment for this picture, as he waits to greet the morning patrons. Fresh meats, canned goods, chewing tobacco, and jars filled with candies and licorice were part of the standard fare of such stores.

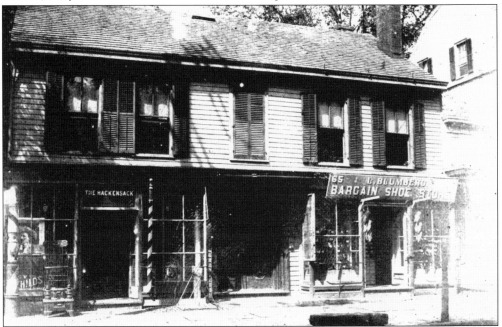

Around 1915, everyone could find what they needed on Main Street. This building, at 65 Main Street, was located adjacent to the grocery store shown at the top of the page. One could get a haircut at the Hackensack Barber Shop or buy a pair of shoes from L. Blumberg's Bargain Shoe Store.

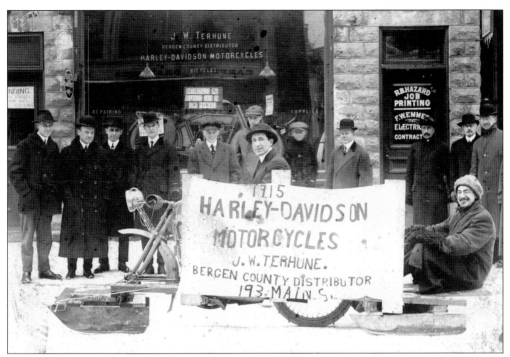

Owning a Harley-Davidson in 1915, much like today, was a dream for many. J. W. Terhune, at 193 Main Street, offered "time payments" to enable cash-strapped potential customers to purchase their own "dream machine." As today, to be in possession of a Harley-Davidson motorcycle was prestigious. Below, members of an early Harley-Davidson riding club, around 1915, are shown wearing the latest in protective gear at the time: goggles, canvas riding jackets, and leather boots.

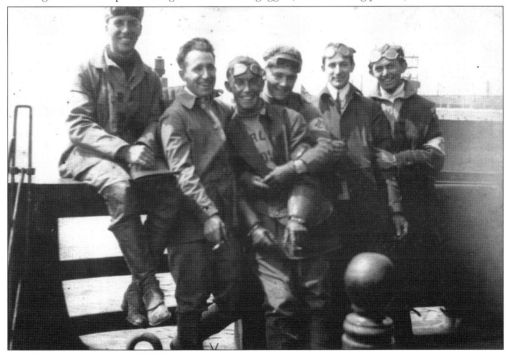

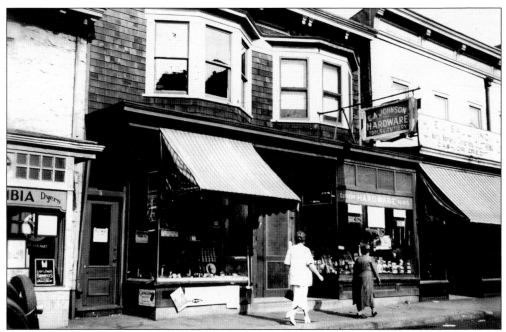

E. A. Johnson Hardware store, at 83 Main Street, was one of several hardware stores that could be found in Hackensack during the early part of the 20th century. Pictured here in 1930, the store sold everything from awls to zinc-plated screws, with the added benefit of having a proprietor who knew his customers on a first-name basis. Most of the mom-and-pop hardware stores in Hackensack are long gone, having given way to the "big box" chain retailers, which became popular in the late 20th century.

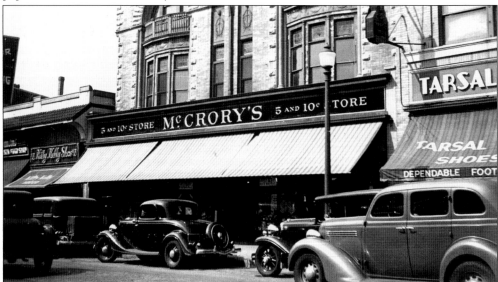

By 1907, the original structure at 153 Main Street had been replaced by the one shown here. It housed McCrory's five-and-dime store on its lower level for many years. Originally it was built by the Independent Order of Odd Fellows as a replacement for its previous meeting hall, which had burned down in 1897. The Odd Fellows met on the upper levels, and were the first so-called "secret order" to organize in Hackensack, having done so in 1845.

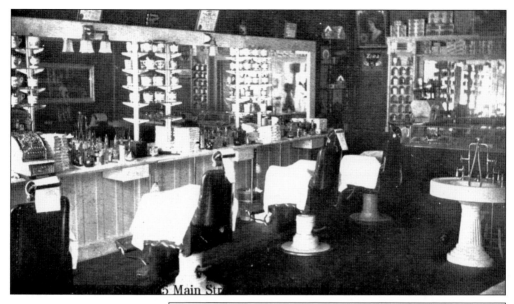

5 Main Str

One of the many barber shops that helped keep Hackensack men well-groomed over the years was the Central Barber Shop located at 113 Main Street and later at 135 Main Street. The going price for a haircut in the 1920s and early 1930s was 20¢. Owners Frank Garofalow and Eugene Miehiline kept a nice tidy shop, and they supplied customers with the latest trolley and railroad schedules, to boot.

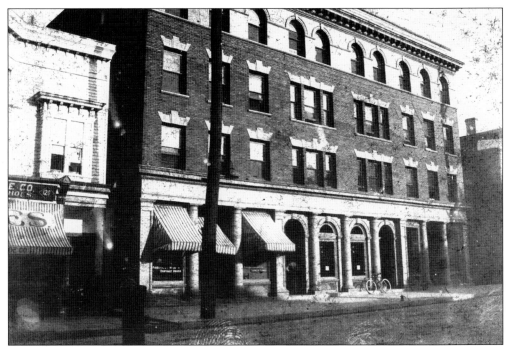

At 120 Main Street, the Hamilton Building was a popular apartment-style residence and a familiar location for formal affairs. Behind the first floor's middle eight windows was a large reception hall used for weddings and other such festive occasions.

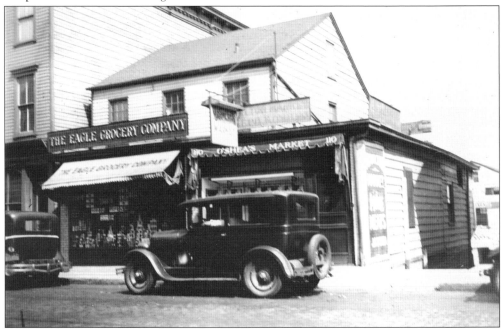

The Eagle Grocery Company, 110 and 112 Main Street, was a convenient place to shop for prepackaged goods, canned items, and basic cooking necessities. In 1930, when this photograph was taken, housewives did not have the luxury of being able to buy everything they needed for their family's weekly meals in a one-stop shopping environment.

Adeline Sellarole, born in Italy, sits proudly as an American in Hackensack in her back yard with her four children, Bob, Teddy, George Jr., and Kathryn. All dressed up to go to church, the family posed for this picture in 1933. The Italians, mostly of the first ward, were just one of many nationalities that settled in Hackensack.

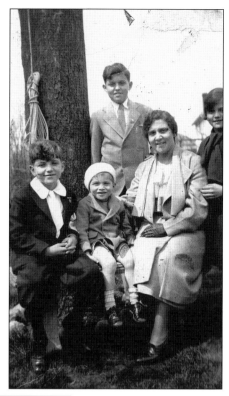

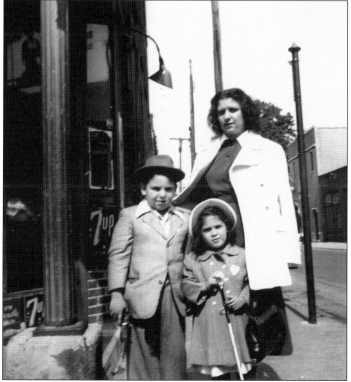

Due to Hackensack's diverse ethnic population, Main Street had its share of specialty food stores. Pictured in this 1953 photograph is Allan Petretti, his sister, Regina, and mother, Josephine, standing in front of Red's Italian Food Market. Red's was one of a number of markets that catered to the growing Italian American community.

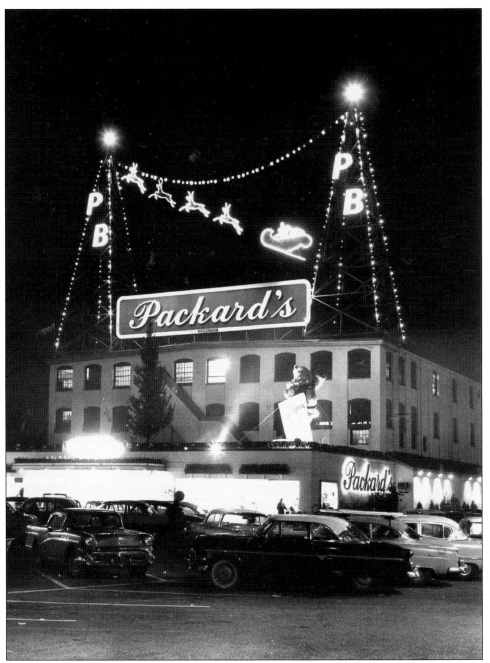

The first true department store in Hackensack was Packard Bamberger's, which was later known simply as Packard's. This store is embedded in the memory of just about everyone who came to shop there from the mid- to late 20th century. At Christmastime, Santa Claus and his reindeer would be strung between the two lofty ironwork towers, which beckoned shoppers with their neon signs, "PB." Packard's sawdust-covered first floor housed a fine bakery, imported gourmet herbs and spices, and a drugstore. Customer's could buy paint, wallpaper, clothing, gardening supplies, or liquor, make travel arrangements, or mail a package in one convenient location. (Courtesy of the Record, Bergen Co., NJ.)

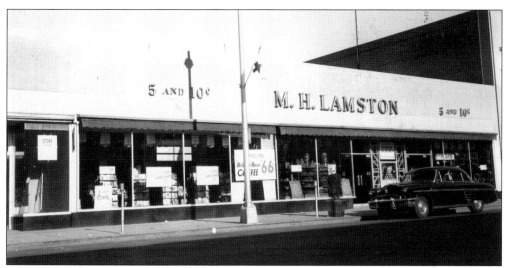

This *c.* 1958 photograph shows M. H. Lamston's five-and-dime store located on Main Street next to Arnold Constable. Lamston's opened June 22, 1951. It offered a variety of items, which included clothing and shoes, thread and cosmetics, dishes, glassware, and more. Its soda shop counters were a refreshing stop for weary shoppers to get an ice-cream soda, a cherry coke, a grilled cheese sandwich, or a burger. With the onset of mall shopping and the reduction of consistent customer patronage, Lamston's closed in the spring of 1977.

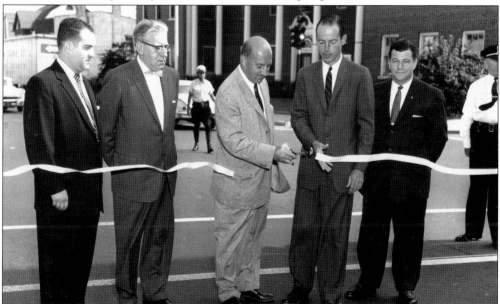

Nineteen storekeepers between Berry and Passaic Streets joined together as the Hackensack Hub Association with the focus of finding various means to entice customers to visit the northern shopping area of Main Street. Free coffee and donuts on Thursdays, fashion shows, a ragamuffin parade for Halloween (which included cider, apples, toys, and balloons), and the Hula-Hoop contest of 1958, were organized to draw customers to their stores. Pictured from left to right in 1958 at the ribbon cutting of the association are Albert Cappellini of M. H. Lampton's, Everett Hanson of Pediforme Shoes, Mayor Peter Frapaul, Charles W. Scranton of Arnold Constable, and Lawrence Friedman of Oppenheim Collins.

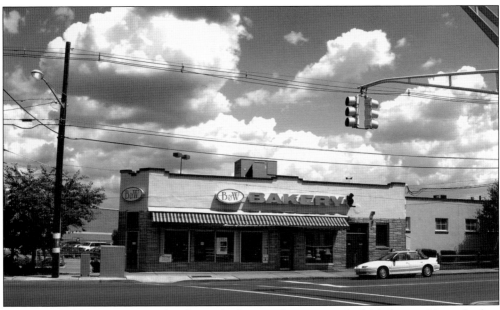

Hackensack, like most towns, has been the home of many wonderful bakeries. If one had to pick the one name that defines baked goods, it has to be B&W Bakery (the initials stand for Boehringer and Weimer), located on upper Main Street. This bakery is famous for its crumb cake and in fact, is advertised as "the home of the heavy crumb cake." It was first introduced in Hackensack in 1948 and today the bakery is a landmark.

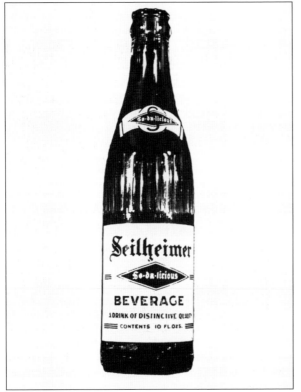

Starting in the late 1880s, Americans began a love affair with soda water. The big names in soda pop, like Coca-Cola and Pepsi-Cola, were known world wide, however, many local communities had their own favorite brand. While not the first homegrown soda, Selhiemer's became extremely popular with adults as well as children. Manufactured on Hudson Street, orange and root beer were said to be the best.

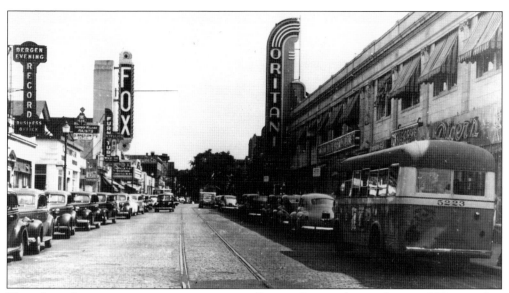

There have been a great many newspapers in Bergen County during the past 200 years, but two main problems were the cause for most of them to have only a brief existence. Those contributing factors were the lack of sufficient subscribers and not having enough advertisers to make the venture a profitable one. The *Record*, however, has been able to survive for more than 100 years and can trace its genesis to 1895. By the 1930s, the *Bergen Evening Record* had moved to 295 Main Street just south of the Fox and Oritani Theaters.

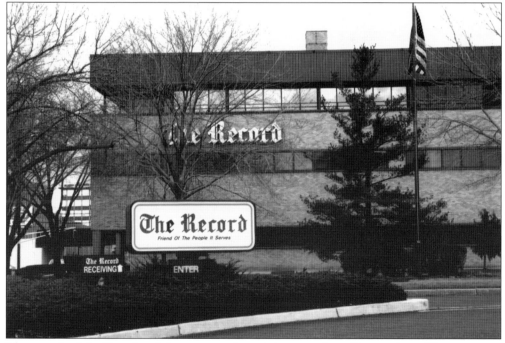

The growth of the *Record* and the amount of prestigious awards and honors its staff has won goes without saying. In 2000, the name North Jersey Media Group was adopted to signify and unify all the different publications and entities that have been newly developed with or acquired under the *Record*. The corporate headquarters is located at 150 River Street.

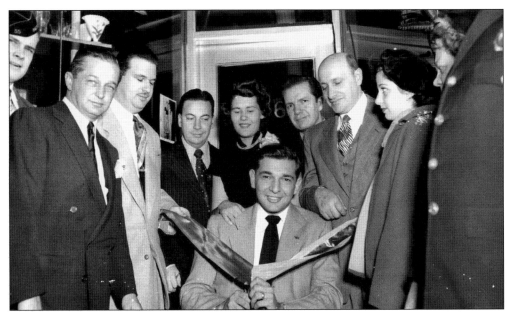

Womrath's Bookstore had its opening day at 326 Main Street on November 9, 1949. Seated holding the ribbon to be cut is Harry Kutik, store owner of the New York franchise. The 52 Week Club, a large group of veterans whose goal was to remember that other veterans were in need 52 weeks per year, approached Womrath's corporate to start a pilot program whose goal was to find businesses to run or opportunities for disabled veterans to help support themselves. Kutik, having been left a paraplegic, wounded the last day of World War II, was the selected candidate. Opening day for Womrath's was a very big deal and many dignitaries were invited. In the photograph above, grouped around Kutik, are, starting fourth from the left going right, Earl Wilson, a big-time columnist; Harry's wife, Carol; Joe E. Adams, radio personality and husband of gossip columnist Cindy Adams; and Hackensack's mayor Peter Frapaul. In 1955, the store moved to its most memorable location at 314 Main Street.

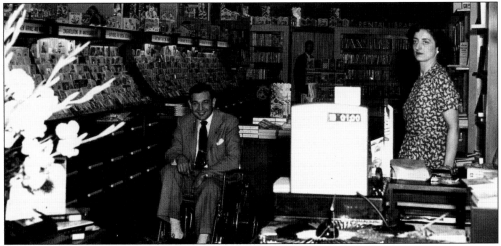

Although the interior of Womrath's Bookstore changed over the years to a degree, patrons would recognize Hackensack's favorite bookstore. Business was good in the 1950s. A sale of $1 was just rung up on the register. After 52 years of selling books, cards, and more, Womrath's closed on November 11, 2001.

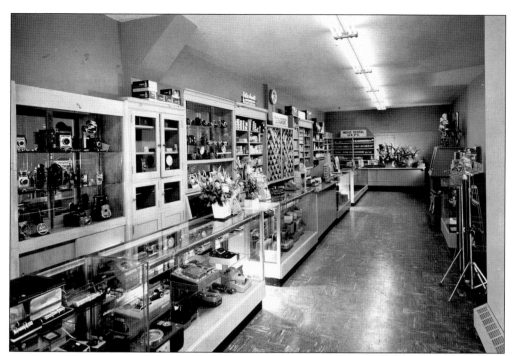

Main Street in Hackensack was the home of many new and innovative businesses. Starting in the 1940s, brothers Vito and Danny Petretti opened Home Movies, later to be known as Main Camera. The store offered a rental library of the latest moving pictures from full-length feature films to silent film favorites. The store remained the place to go for camera and film buffs for more than four decades.

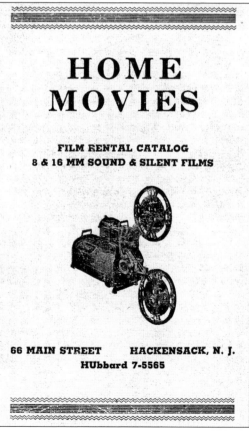

HOME MOVIES

FILM RENTAL CATALOG
8 & 16 MM SOUND & SILENT FILMS

66 MAIN STREET HACKENSACK, N. J.
HUbbard 7-5565

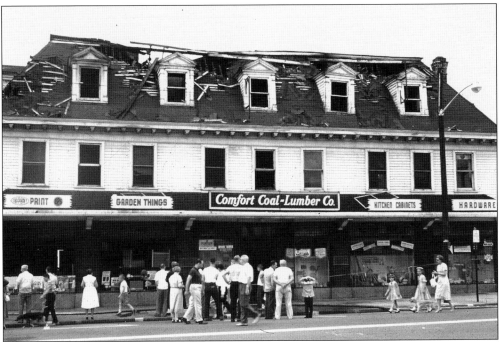

The Comfort Coal and Lumber Company, located in the vicinity of Anderson, Passaic, and Linden Streets, was one of the finest and largest lumber and hardware supply stores in northern Bergen County. During the 1950s, two children playing with matches accidentally set the building on fire, which destroyed it completely. It blazed for hours and huge flames and thick black smoke could be seen for miles. The heat was so intense that vehicles parked in the rear were melted, with ash left piled high against their tires.

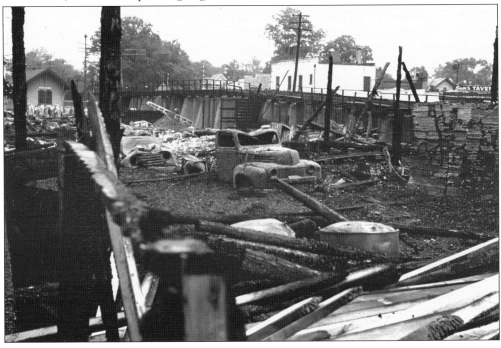

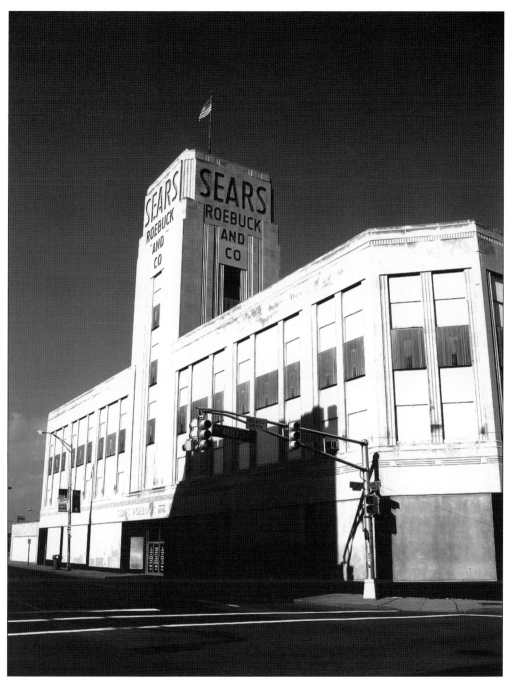

When Sears, Roebuck and Company opened in 1932, it was declared the largest department store in Bergen County. Adorned with its art deco tower, it quickly became a prominent landmark at the northern end of Main Street at Anderson Street. With its reputation for high-quality products and customer satisfaction in Hackensack through much of the 20th century, Sears was the highlight of a typical shopping experience. This building is situated on land that had been previously owned and lived on by Sen. William Johnson, Hackensack's most noted philanthropist at the beginning of the 20th century.

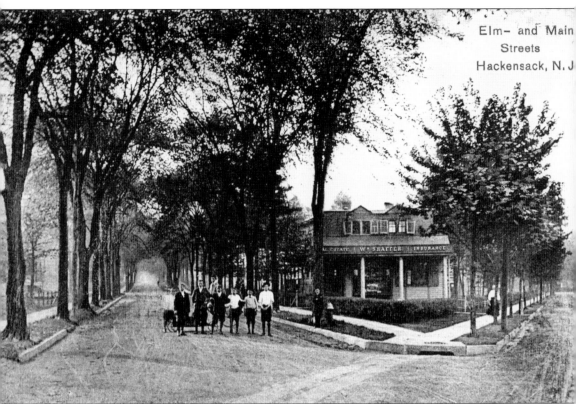

Hackensack's inevitable suburban expansion into the farmland area of Cherry Hill, later to be known as the Fairmount area, brought with it the need to have agents handle the newly developed real estate. One of the best-known and longest-running real estate offices in the area was the W. Shaffer Real Estate Office located on the corner of Main and Elm Streets. This distinctive little cottage-style house, which still stands on its original site, provides a unique backdrop for the group of boys in this 1910 photograph.

For nearly 100 years, there has always been at least one shoe repair shop on Anderson Street. Since 1964, it has been S&J Shoe Repair. Sandra Romano and her husband, Joe (thus the name S&J), had their first store at 104 Anderson Street before moving in 1985 to 80A on the same block. Besides mending shoes, belts, luggage, purses, and even leather coats, in the 1960s Joe was a hit making original one-of-a-kind sandals and belts for the hippie generation. With their son Joe Jr., they have extended their business to include shoe repairs for major department stores in the area and altering shoes to include medically prescribed orthopedic build-ups.

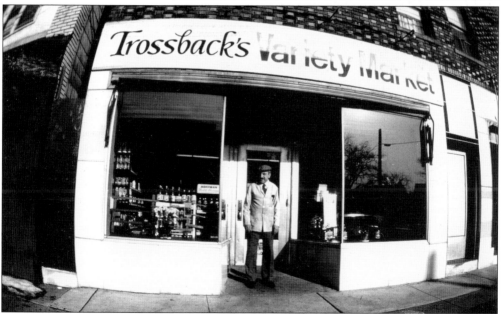

Trossback's Variety Market, located in the Fairmount area at 602 Main Street, opened its doors in 1912 offering the finest meats, cold cuts, produce, and pantry staples. Home delivery of groceries was offered, and from 1939, most if not all were delivered by Nicholas J. (Nick) Guerra. Having been a loyal employee, Guerra was offered to take over the business when Frank Trossback retired in the early 1970s. Guerra and his family continued the business until his own retirement in 1987.

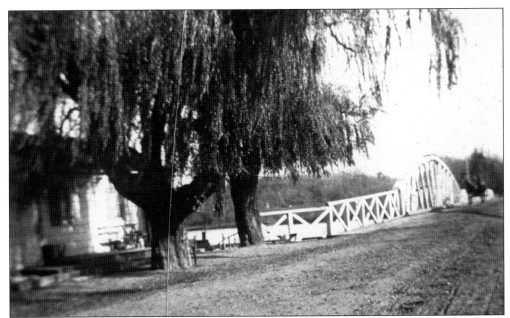

One of the earliest and most notable bridges allowing access into Hackensack is the Anderson Street Bridge. Records indicate that the original bridge was built on the site in 1858. This very early photograph shows the bridge with its wood railing and dirt roadway. A horse-drawn carriage can barely be seen coming across it and entering Hackensack. Note the two large willow trees on the left.

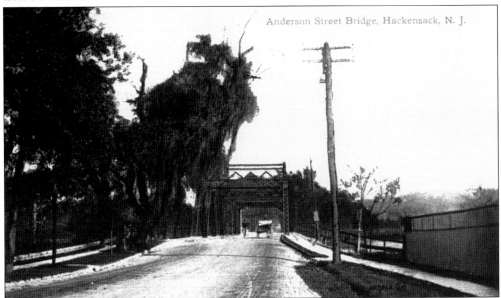

Anderson Street Bridge, Hackensack, N. J.

One can see the new and improved Anderson Street Bridge, around 1907, with steel replacing the wood railing. The upgrading of the bridge was necessary considering it was a very busy access road into Hackensack from Bogota and Teaneck. One can see a more modern horse and buggy, as well as the two distinctive willow trees. When entering Hackensack today, going over this bridge and passing over River Street, the Sears building greets the traveler on the corner of Main and Anderson Streets.

Three

ATHLETICS AND PASTIMES

In the years following the Civil War, America began to prosper and grow. Many citizens started having time to enjoy life and to be entertained. It was in the late 1800s and early 1900s that leisure travel, recreation, and sports had become a large part of the American pastime. Hotels and inns, restaurants and eateries, ball fields and stadiums all began appearing on the country's roadsides. Hackensack was no exception.

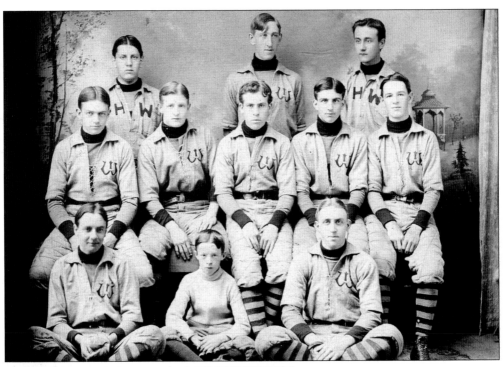

VOL. IV. HACKENSACK, JANUARY, 1903. No. 10.

WALTER VAN SAUN,
Member of Board of Governors.

The Hackensack Wheelmen's club was organized in February 1895 with over 150 members, but tripled its membership within a few years. In 1896, it joined the Association of Cycling Clubs of New Jersey. This club had an excellent cycling team with many competitions throughout the state. It also had a football team and a baseball team. Seen here is the 1898 baseball team posing for their annual professional team photograph. The Hackensack Wheelmen's activities and news were so plentiful that a monthly publication was needed. Dances and banquets were held on a regular basis. A billiard hall and poolroom held just some of the activities offered to the members and their guests. Bowling was later introduced in 1902 and many teams emerged from within the club.

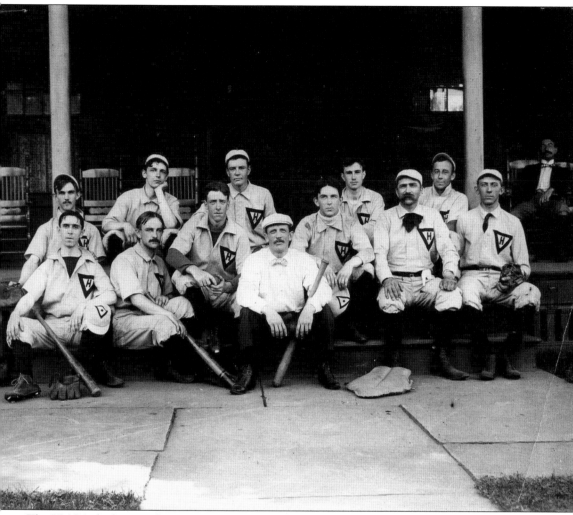

The YMCA for boys and young men in Hackensack was organized around 1890, but operated under the name of Social Service Work prior to 1917. This organization's work was conducted in a building at the corner of State and Warren Streets. In August 1917, it was decided that a community YMCA was to replace this organization and move to a new location. The new building's location, at 360 Main Street, was dedicated on February 12, 1928, and has served the community for 80 years. Its purpose and offerings have changed throughout the years to complement the needs of the growing community. The "Y" continues to be a vital cornerstone of the community by providing recreational activities, camping, educational enrichment, and by fostering good moral standings. Irving Berlin may have said it best when he composed "I Can Always Find a Little Sunshine in the Y.M.C.A." Hackensack had a number of baseball clubs and organizations that competed in town. Pictured is the YMCA's first baseball team, organized in 1897.

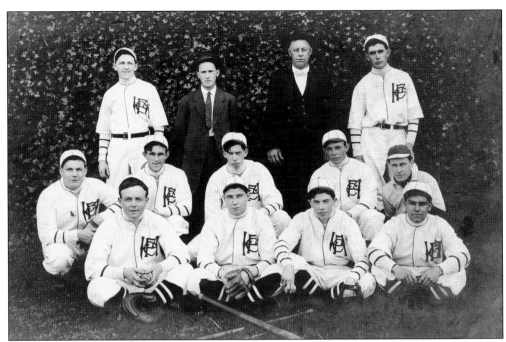

In the early 1900s, baseball was quickly becoming America's favorite pastime. People just could not get enough of it, so clubs and organizations started their own favorite teams. Many surrounding towns were also organizing baseball teams, with many games scheduled and rivalries beginning too, which made going to a game even more exciting for their fans. The Hackensack Field Club started a baseball team as shown in the *c*. 1900 photograph above. Below is the Hackensack Field Club's 1912 baseball team. A larger organization is seen in this photograph with the same amount of ballplayers. As in all the baseball photographs shown, only 10 or 11 players were on the roster in the early days, not leaving much room for substitutions for injuries.

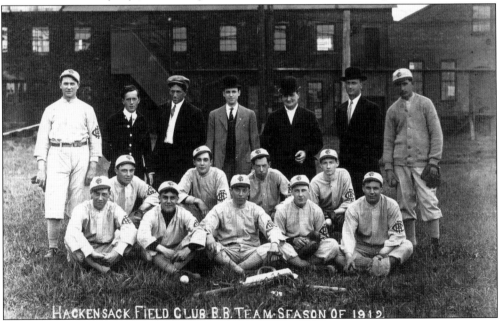

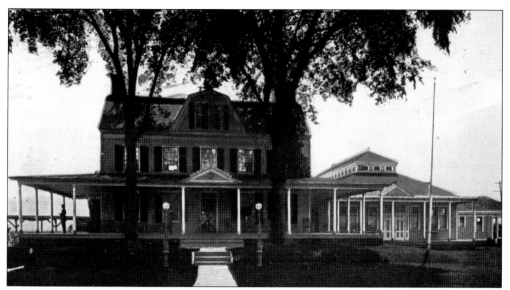

The Oritani Field Club was one of New Jersey's most prestigious social clubs. It was organized and incorporated in 1887. The Oritani property encompassed 10 acres of farmland. It included 222 feet on Main Street and was bordered by Camden Street and extended to the Hackensack River. This complex consisted of a clubhouse, a banquet and dance hall, a baseball field and grandstand, eight tennis courts, a toboggan slide, and an ice-skating pond. There was also a multislip boathouse on the river, which accommodated 100 boats. As the years progressed, members voted to expand the activities, and in 1922, a swimming pool, bowling alleys, and a billiard room were constructed. It was in 1926 that part of the land was sold to the city for the Main Street development of stores and for the building of the grand Oritani Theater. Property continued to be sold off. River Street was completed, which paralleled Main Street, and Foschini Park was formed. Although smaller than times past, the Oritani Field Club still exists at 18 Camden Street.

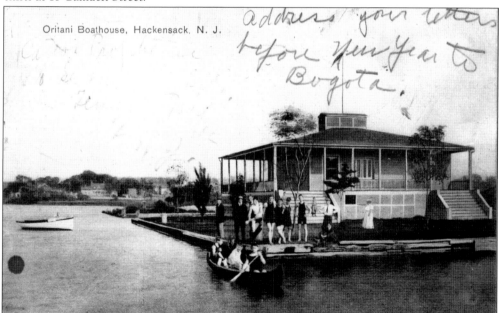

Oritani Boathouse, Hackensack, N. J.

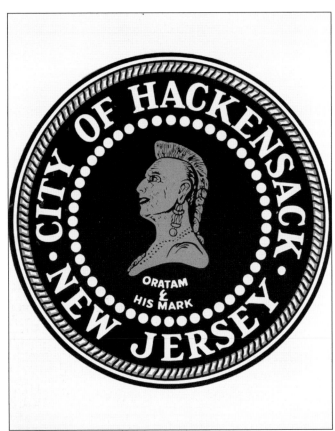

The seal of Hackensack has been in existence for decades. In the center of the seal is a portrait of Chief Oratam, the leader of the Achkenheshacky Indians of the Lenni-Lenape tribe. Few in this city realize how the name of Oritani came to be. One of the first orders of business for the field club in 1887 was to come up with a name. Many names were suggested, however, in honor of Chief Oratam, with a slight change to his name, Oritani was overwhelmingly the choice. Since then the name has been used for many businesses such as the Oritani Theater and the Oritani Savings Bank. Pictured below is the Oritani Field Club's 1915 baseball team. Their baseball schedule was busy, as many clubs and organizations in town, and in surrounding towns, had teams of their own.

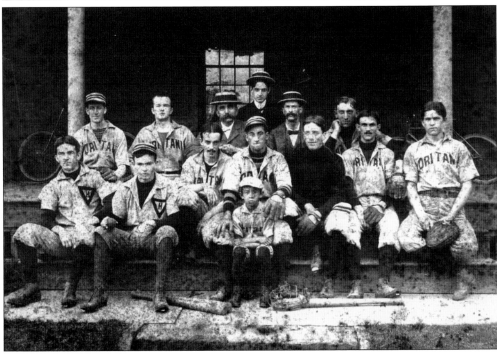

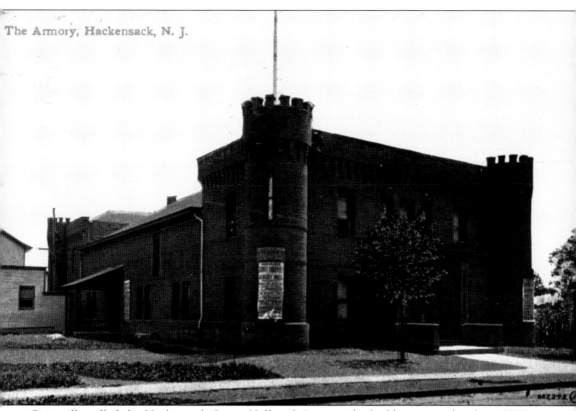

The Armory, Hackensack, N. J.

Originally called the Hackensack Opera Hall and Armory, the building opened in June 1888 and burned to the ground in 1901. The new armory (pictured), at 174 State Street, opened with fanfare on July 4, 1902. This building, one of the few large enough to hold sizable crowds, held graduations, lectures, dances, basketball games, boxing matches, and amateur theatrical productions. Weekly drills were also conducted here by the state national guard.

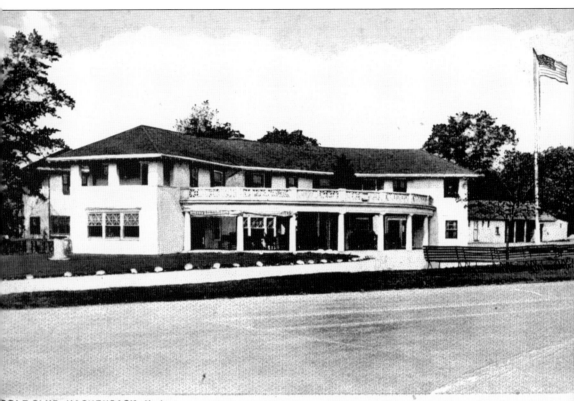

GOLF CLUB, HACKENSACK, N. J.

It was in 1899 that the Hackensack Golf Club was incorporated. It spanned 250 acres by its completion in 1915. The location was bordered west of Summit Avenue, north of Central Avenue, and south of Passaic Street, reaching the Maywood border with Coles Brook running through five of the holes. The clubhouse (pictured), with its wide veranda, was completed in May 1900. This white stucco building was heated and used all year round. There was a large dining area and a room for billiard and pool tables. The lower level had a locker room with bathing facilities and a comfortable sitting area. Municipalities took the property in 1928 when the Hackensack Golf Club closed. Years later, the clubhouse was used as the Hackensack Civic Center. Around 1970, the building was razed, and later a much-needed elementary school was constructed at this location. Today the Hackensack Golf Club is located in Oradell off Kinderkamack Road.

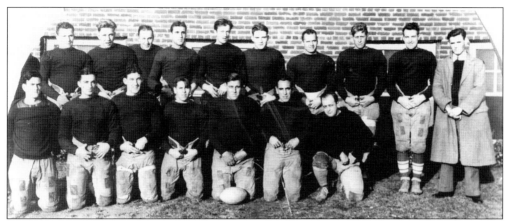

For those athletes who could not get football out of their system, this photograph shows one of many high school alumni football teams in full gear. A Sunday afternoon football schedule allowed theses graduates and others to continue their athletic talents and strengthen their camaraderie, even after graduation.

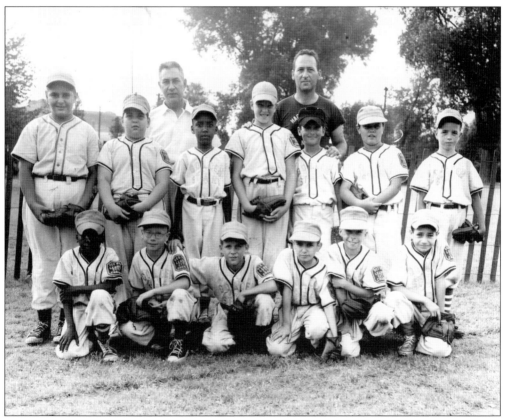

This team was the Pee Wee League city champs, posing with their coaches here in the 1950s. Hackensack has an extensive Junior Sports Program with the Pee Wee League, Little League, and Babe Ruth League. The program allowed children of various ages to learn to play the game of baseball. By the time these students got to high school, many excelled, having had several years of experience.

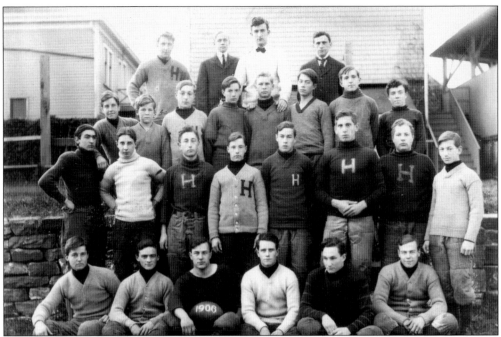

In 1902, Hackensack High School challenged Stevens Academy, which became the first high school football game ever played in Bergen County. Pictured is the 1906 Hackensack High School football team. They were then known as the Hackensack Colts, but in 1910, Halley's Comet became world-wide news and soon after, Hackensack High School adopted its new name. The Hackensack Comets name is still used to this day.

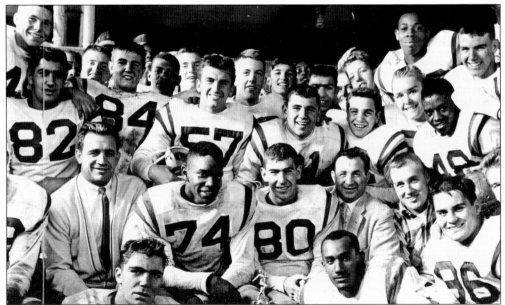

Coach Carl Padovano, coach Thomas Della Torre (head coach for 22 years), and coach Paul Fulton are surrounded by a victorious 1960 Hackensack football team. The Comets had just defeated their arch rivals, the Teaneck Highwaymen. This always-exciting Thanksgiving Day rivalry continues with 77 games played so far and is the second longest streak in New Jersey.

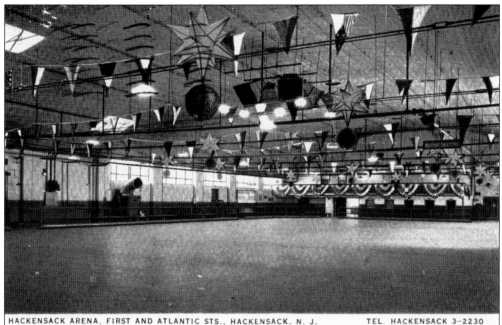

HACKENSACK ARENA, FIRST AND ATLANTIC STS., HACKENSACK, N. J.　　　TEL. HACKENSACK 3-2230

The Hackensack Arena, shown here in 1936, was located on the corner of First and Atlantic Streets. Also known as the Hackensack Roller Rink and America on Wheels, this favorite local amusement site often sponsored special events such as ladies night and the famous Grand Skating Night Carnival featuring organ and piano music. Many of Hackensack's young men of the time would remember taking their date to a special skating event at the rink. Today with the expansion of Hackensack University Medical Center, the original building has been torn down.

Phone: HACK. 3-2230

THIS TICKET EXPIRES MAY 21, 1939

Simplex T. & P. Co., Inc. New York 169

SPECIAL LADIES ADMISSION TICKET SUNDAY NIGHTS ONLY

ROLLER SKATING
NEW FLOOR — ORGAN AND PIANO MUSIC — NEW SKATES

HACKENSACK ARENA
FIRST AND ATLANTIC STS.　　　HACKENSACK, N. J.

Wardrobe 25c and Skates 10c
WITH THIS TICKET
SEE OTHER SIDE

3173

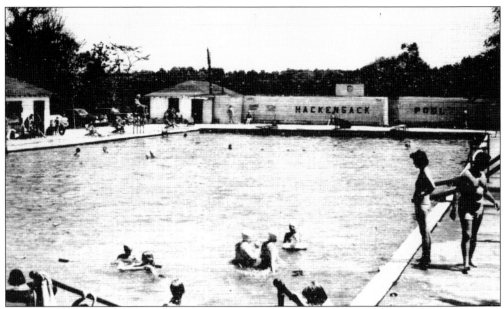

During the 1940s and 1950s, the summer retreat from the heat was the Hackensack Swim Club or simply referred to as the Hackensack pool. Located on River Street just north of Sears, Roebuck and Company, the pool was a local favorite for children and adults seeking a cool dip during the heat of the summer. During the late 1950s, the club faced some very difficult community and membership issues and closed its gates. Today a car dealership is located on the site, however, some still say if they try real hard when passing the site, they can still smell the hot dogs grilling at the snack bar.

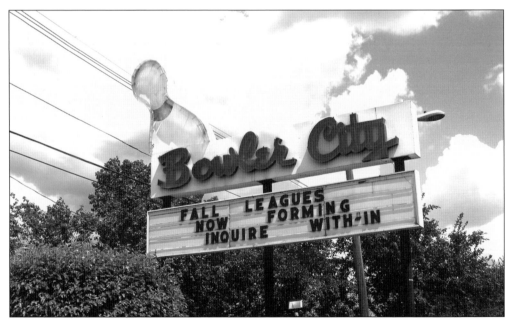

Bowler City has offered years of recreation to the public and bowling league members. This popular building was constructed in 1958 across the street from Foschini Park on Midtown Bridge Approach.

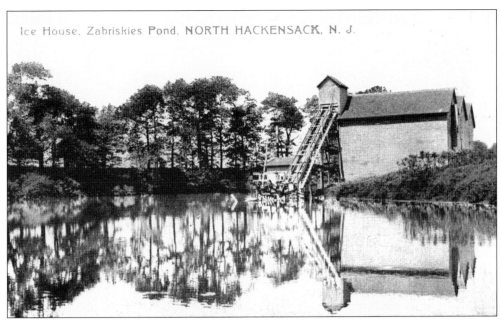

Ice House, Zabriskies Pond, NORTH HACKENSACK, N. J.

One of the most popular winter activities in Hackensack during the first third of the 20th century was ice-skating. While Hackensack had a number of places to skate, like the river and Borg's Pond, the most popular and most remembered is Zabriskie's Pond, shown here. After huddling around a warm fire, getting ready to hit the ice again, skaters would venture back out to have a chance at being the tail end of "the whip." The pond also had an icehouse that enabled blocks of ice to be transported to Hackensack residents by horse and buggy, and later by truck, to be placed in their iceboxes to keep the contents cool.

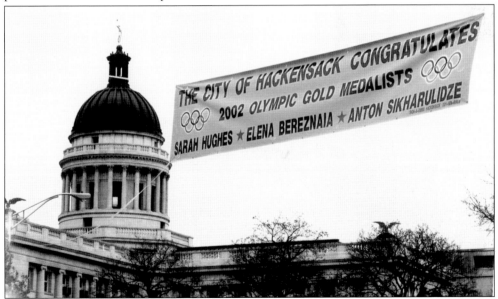

Today, the Ice House, with four indoor ice rinks, is located on Midtown Bridge Approach close to the Hackensack River. Many schools, hockey teams, and Olympic hopefuls use this rink. In 2002, the year of the Salt Lake City Olympics, the Ice House was the practice ice for three gold-medal winners.

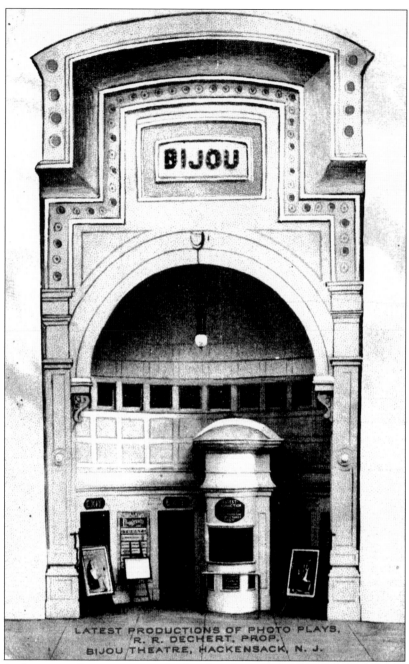

LATEST PRODUCTIONS OF PHOTO PLAYS,
R. R. DECHERT, PROP.
BIJOU THEATRE, HACKENSACK, N. J.

In 1903, the first movie theater was opened in Los Angeles and featured two of Thomas Edison's first motion pictures. *The Great Train Robbery* and *American Fireman*, both short films, were produced in Fort Lee, which is located within a few miles of Hackensack. However, it was not until 1907 that Hackensack featured moving films at a place called the Edsonia, located at 55 Main Street. The program boasted scenes of travel, mystery, drama, and comedy. After the Edsonia, other theaters for motion picture viewing and Vaudeville acts appeared in Hackensack at the Hudson on Hudson Street, the Royale located at Main and Bergen Streets, the Bijou (shown above) at 170 Main Street, and the Crown on Anderson Street, east of the railroad tracks.

The most memorable of all the early Hackensack theaters was indeed the Lyric Theater on Main Street, just south of Mercer Street. The Lyric featured moving pictures as well as Vaudeville. It was the top-of-the-line of all theaters for its day. Box seats, chandeliers, and lush carpets made it special for its opening night on June 30, 1913. The postcard to the right features the Thanhouser Kid, who was one of the performers at the Lyric. This postcard was part of a set that the Lyric gave to patrons showing upcoming acts and feature performers. The Lyric presented all forms of entertainment including the symphony. Shown below is a ticket from January 6, 1924, featuring the Bergen County Symphony Orchestra. With the slow demise of vaudeville and the depression of the 1930s, the Lyric tried to remain open featuring dramatic plays with some top-named actors, but eventually closed its doors around 1930. Hackensack's next theater was the Eureka, which was located on the north side of Banta Place near State Street and resembled the overall look of the Lyric with that touch of class and featured a balcony.

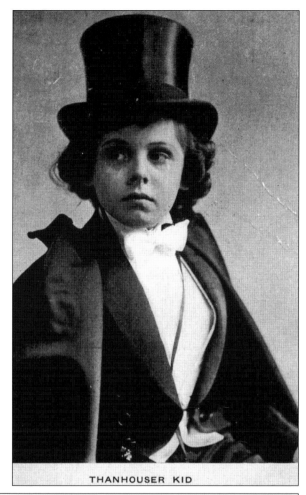

THANHOUSER KID

BERGEN COUNTY SYMPHONY ORCHESTRA HACKENSACK

THROUGH ITS PATRONS AND SUBSCRIBERS EXTENDS TO THE HOLDER OF THIS INVITATION ADMISSION TO THE FIRST CONCERT

AT THE

LYRIC THEATRE

ON

SUNDAY, JANUARY 6, 1924
3 P. M.

Bring Your Girl
- - TO - -
HACKENSACK

There's Fun Enough Here for Both.

Hackensack's status as the hub of Bergen County was certainly not limited to the courthouse and government activities. The long expanse of Main Street with shopping, restaurants, and theaters drew large crowds, especially on Saturday night. As the place to go and be seen, many a visitor would send home a postcard to family and friends to show them the good time they were having in Hackensack. These generic postcards were very popular during a time when the postcard was an important part of communication.

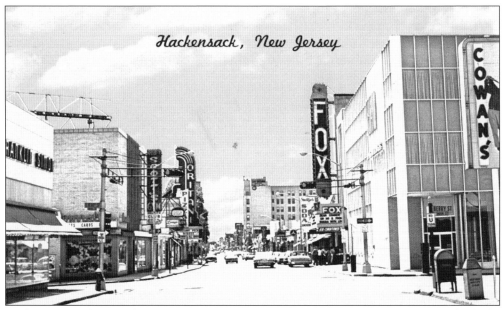

Hackensack, New Jersey

In this *c.* 1963 photograph of Main Street in Hackensack, looking south, one can view both the Fox and Oritani Theaters. Scott's Gym on the left was next to Womrath's Bookstore. The gym was originally the Vic Tanny Gym.

Our instant communication society today makes it very difficult to understand how important the postcard was as a means of communication. Even to family and friends who lived just a short distance away, picture postcards and generic city cards like this were used in much the same way e-mail is today, with delivery of posted mail taking place twice a day.

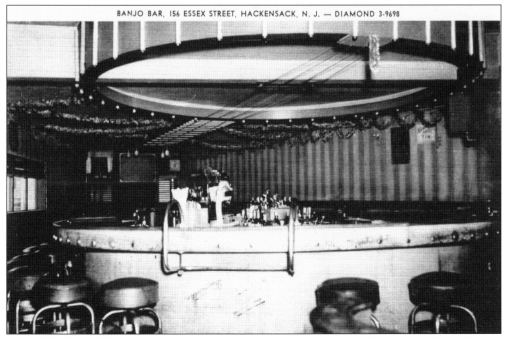

BANJO BAR, 156 ESSEX STREET, HACKENSACK, N. J. — DIAMOND 3-9698

One of Hackensack's more famous watering holes of the past was the Banjo Bar, shown here in the 1940s. The novelty with this local drinking establishment was the banjo shaped ceiling and bar. It was located just east of the railroad tracks on Essex Street.

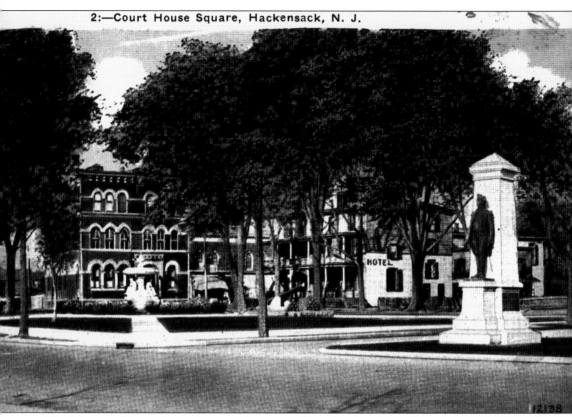

The Mansion House, located across the street from the Green on the corner of Main and Washington Streets, was used as a hotel in the early 1900s. Guests had access to the stables and a café. Despite its long Hackensack history, it was torn down in 1946.

Susquehanna Hotel

HERMANN ABBENSETH, Proprietor.

MAIN STREET, OPP. N. Y. S. & W. R. R. DEPOT,

OYSTER & CHOP HOUSE. Telephone Call: 58 A.

IMPORTED WINES, LIQUORS and CIGARS. **HACKENSACK, N. J.**

Shown above is an advertisement from the early 1900s for the Susquehanna Hotel, located on Main Street. This popular hotel had exquisite dining facilities and was a favorite place to stay for celebrities visiting Hackensack for social, educational, and cultural events.

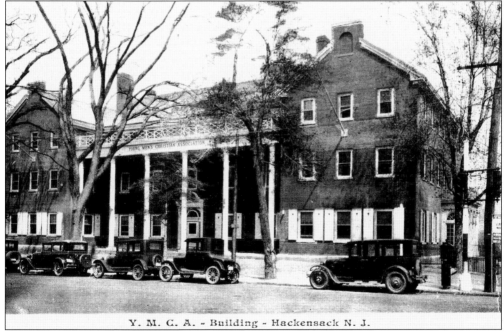

Y. M. C. A. - Building - Hackensack N. J.

Just as when the YMCA at 360 Main Street was opened in 1928, today its facade is in the style of neo-federalist revival, symmetrical with large white pillars. At that time, it contained a cafeteria, swimming pool, and three gyms, one with a stage. From 1916 until the late 1950s, boarding rooms were designed into every new YMCA building in the country so newcomers coming to any city that had a YMCA would have a temporary place to stay while seeking permanent housing. Following the crash of 1929, the YMCA in Hackensack offered local residents an inexpensive place to eat in its cafeteria.

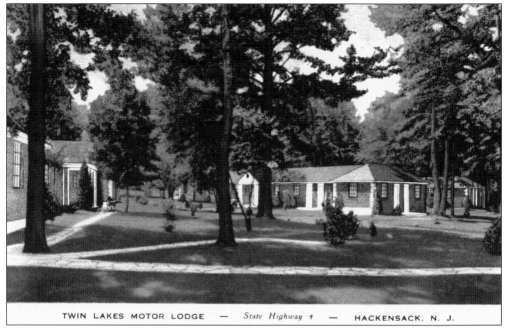

TWIN LAKES MOTOR LODGE — *State Highway 4* — HACKENSACK. N. J.

Major highways going through Hackensack were always popular places for motor lodges. During the 1950s, the Twin Lakes Motor Lodge on Route 4 was only six miles from the George Washing Bridge. It had a shower in every room and was considered the most modern of tourist accommodations.

The Oritani Motor Hotel was located just off busy Route 4 in Hackensack. Shown here in the 1960s, the management billed the establishment as being "Among the finest in the country," with radio, television, telephone, and air conditioning in every room.

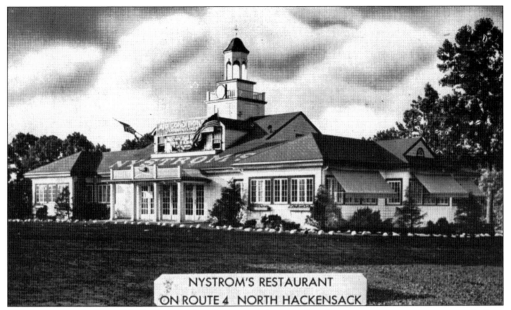

NYSTROM'S RESTAURANT
ON ROUTE 4 NORTH HACKENSACK

While motor lodges filled the needs of tourists in search of rest, restaurants were needed to fill hungry stomachs. Located just down the highway from the Twin Lakes Motor Lodge on Route 4 was Nystrom's Restaurant, shown here in the 1950s. Nystrom's famous restaurant was a Hackensack institution for many years.

In 1929, the Elk's Club of Hackensack erected an impressive and much larger building at 375 Union Street. The very beautiful dining room known as the Collonade Room served a buffet luncheon for $1.15 and full-course dinners from $2.25. The Elk's Club was a favorite lunch spot for Hackensack businessmen for many years.

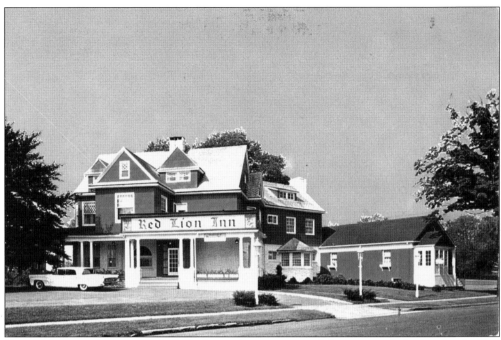

One of the most distinctive of all Hackensack restaurants of the past surely had to be the Red Lion Inn located on the corner of Main Street and Euclid Avenue and shown here with both interior and exterior views in 1968. One of the signatures of the restaurant, in addition to its fine food, was the sprawling Red Maple that graced its front lawn. Both the tree and the restaurant remained a landmark until the building was destroyed by a fire in the early 1970s. Never rebuilt, it remains only a fond memory in Hackensack's long history of hospitality.

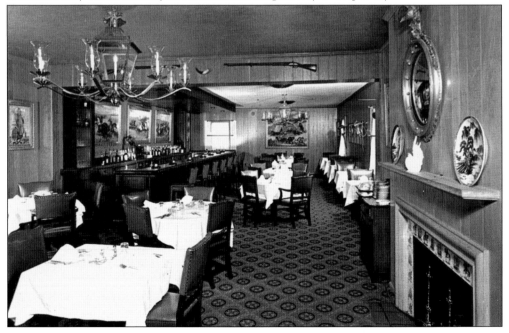

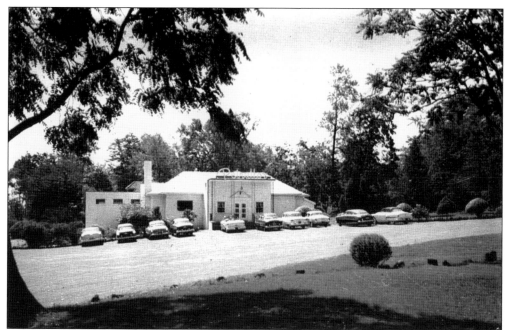

One of Hackensack's more popular and upscale cocktail lounges and restaurants was Petrullo's Everglades, shown here in the 1950s. It was located on the corner of Essex Street and Polify Road. This was at one time the site of the Newman School, which was an elite private preparatory school where F. Scott Fitzgerald, one of America's greatest writers, was enrolled.

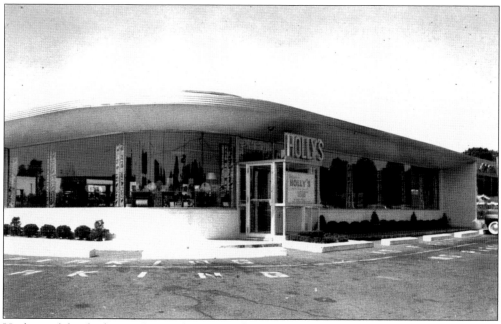

Hackensack has had many famous diners over the years, but during the 1950s and 1960s, the place to go for a great meal was Holly's located on Route 4 at Hackensack Avenue. This local favorite was famous for its fountain and desserts. Today this is the site of the Coach House Diner.

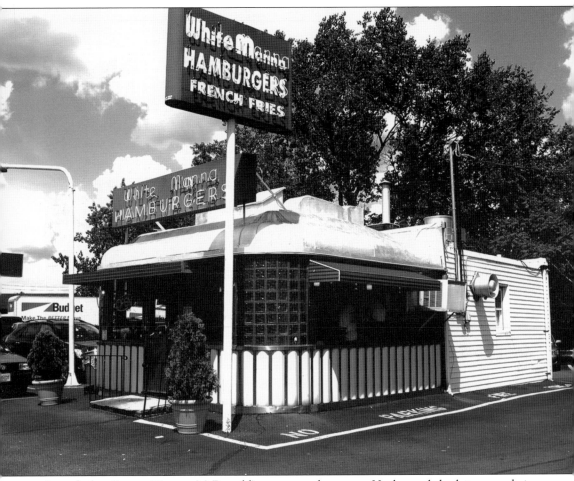

Long before Burger King or McDonald's came on the scene, Hackensack had its own shrine to that most famous of all American snacks—the hamburger. The White Manna started its life at the 1939–1940 New York World's Fair. After the fair, it was moved to this location on River Street where it remains as popular as ever to this day. With recent exposure on the Food Network and in historical books, customers often wait in line outside for a spot at the counter.

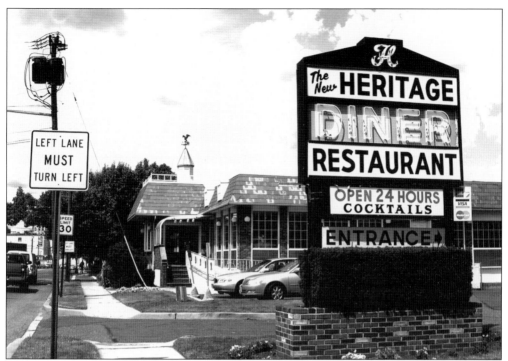

While Hackensack has never been considered a dining mecca, it has had its fair share of great places to have a memorable meal over the years. The Arena (shown below), on the corner of First and Essex Streets, was once the location of Charcoal Corners. The Heritage Diner (shown above) on River Street is now a landmark. Names like Petrullo's Everglades, Pinto's, the Famous Deli, Packard's Print Room Restaurant, and Lido are only a few of the many restaurants to have served Hackensack residents over the years. Today the Stony Hill Inn, Dinallo's, and Rudy's have become Hackensack institutions for dining.

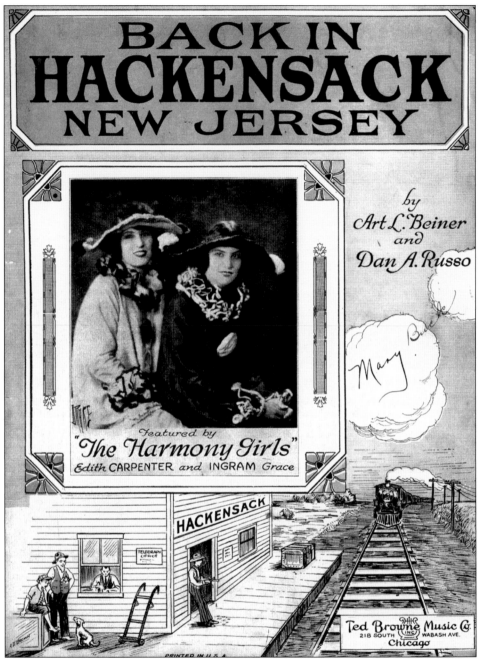

Hackensack—what an interesting sounding town. There were, and are, many songwriters and script writers that seem to love this rhyming and consonant filled word. The name has been used in songs and movies for decades by such notables as Cole Porter, Julie Styne, Billy Joel, Jimmy Hendrix, Jim Croce, and Fountains of Wayne, just to name a few. Whether pop and rock, country and folk, or heavy metal and show tunes, Hackensack keeps showing up in all styles of music. Hollywood has also noticed the city of Hackensack. A few of the many movies that scripted this town are, *Brewster's Millions* (1985), *Superman* (1978), *Calamity Jane* (1953), *The Time of Your Life* (1948), *The Killers* (1946), and *The Palm Beach Story* (1942).

Four

HACKENSACK DEFINED

The city of Hackensack is rich with an abundance of history and citizens who are passionate to preserve it. Many are the stories of the city as it continues to unfold. During the past 300 years, people have come to Hackensack for many different reasons. At the end of the 19th century, people were seeking a sense of being in the country, the mid-20th century saw the rise of suburban living at its finest, and today Hackensack's close proximity to the bustling New York City makes it the commuter's ideal place to live. Together this mix of tradition, culture, and aptitude has formed the county seat. All can be proud of this city named Hackensack and its continual coming of age.

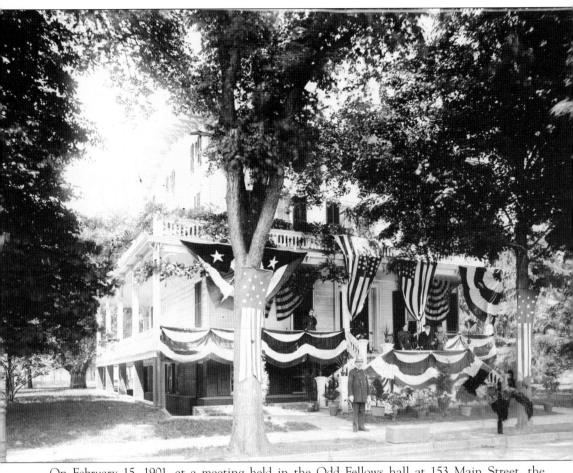

On February 15, 1901, at a meeting held in the Odd Fellows hall at 153 Main Street, the Hackensack Order of the Elks was organized. It was identified as the Grand Lodge of the Benevolent and Protective Order of the Elks (BPOE) No. 658. Located at the corner of State and Gamewell Streets, it had a grand porch suitable for meetings and grandstanding.

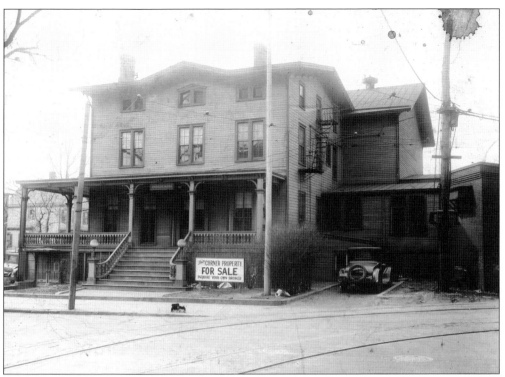

In 1929, the Elks decided they needed a larger facility. The building shown above on Gamewell Street was listed for sale. A new lodge was envisioned and soon after was to be constructed on Union Street.

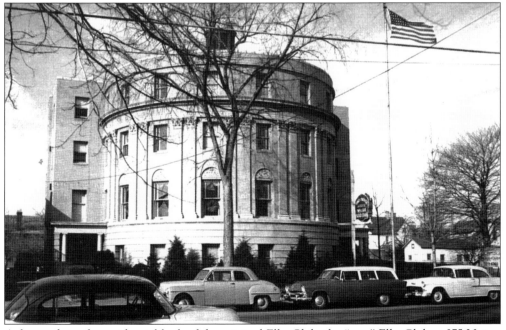

A far cry from the residential look of the original Elks Club, the "new" Elks Club at 375 Union Street was the envy of every Elks Club in the country.

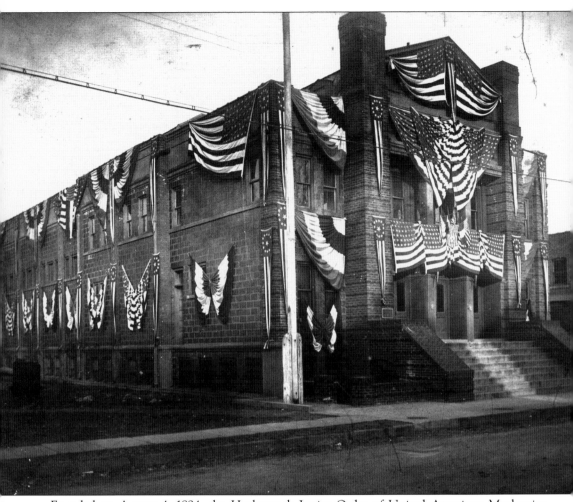

Founded on August 4, 1894, the Hackensack Junior Order of United American Mechanics was organized and originally held their meetings at the Odd Fellows hall at 153 Main Street. The Junior Order of United American Mechanics was a civic organization dedicated to "the education of all classes, in patriotic love of our country and its flag." The hall would often lend its facility to other similar dedicated groups. Such an instance was the 25th anniversary of the Free Mason's (date unknown). Although very patriotically draped in the nation's stars and stripes, today such bunting and positioning of the America flag would not be proper based on the congressional legislation detailing how the U.S. flag may be displayed. All viewings of the American flag must always be stars to the upper left, never to the right.

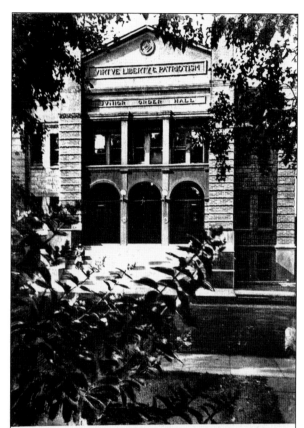

Over the years, one of Hackensack's more impressive structures was the Junior Order hall. To accommodate the group's rapidly increasing membership this hall was built. Its massive size allowed it to be used for many of Hackensack's celebrations and special events.

Hall of the Junior Order of the United American Mechanics, Hackensack, N. J.

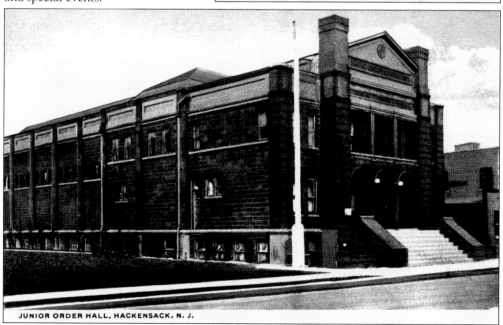

JUNIOR ORDER HALL, HACKENSACK, N. J.

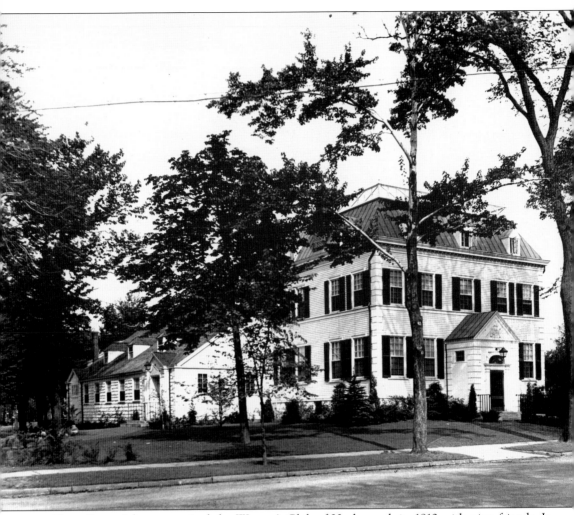

Flora Curry Adams organized the Women's Club of Hackensack in 1912 with nine friends. It eventually grew to more than 700 members. After many years of planning and hard work, the Women's Club house on Union Street was dedicated in 1931. The architect of this beautiful building on Union Street was Wesley S. Bessell. The extension shown on the left side of the building housed the auditorium. The Women's Club of Hackensack had a long and dedicated history of mutual help, fellowship, and community service. Sadly, this charming clubhouse no longer exists.

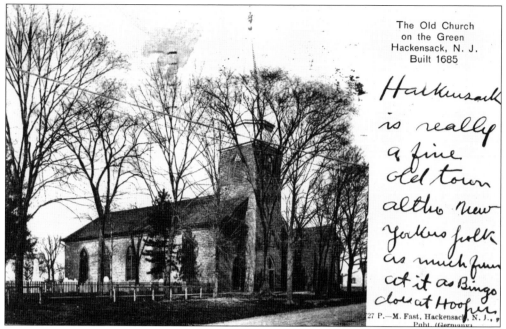

The Old Church
on the Green
Hackensack, N. J.
Built 1685

Hackensack is really a fine old town altho new Yorkers folk as much fun at it as Bingo does at Hoofer.

27 P.—M. Fast, Hackensack, N. J.,
Publ. (Germany)

Hackensack's most historic landmark and still-remaining building is the Church on the Green, built in 1696. The adjacent cemetery is the final resting place of Brig. Gen. Enoch Poor, who served the developing nation during the American Revolution along with other early patriots. Today this beautiful church stands strong after over 300 years of service.

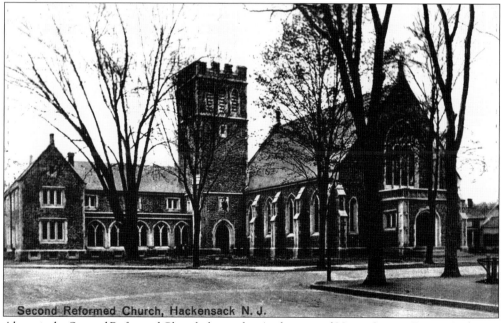

Second Reformed Church, Hackensack N. J.

Above is the Second Reformed Church, located at Anderson and Union Streets. Facing Anderson Street Park, this beautiful church is noted for its famous leaded glass Tiffany windows.

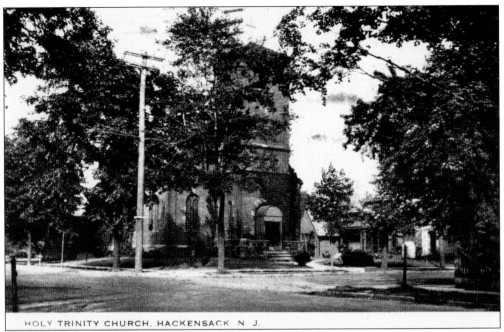

HOLY TRINITY CHURCH, HACKENSACK N. J.

Shown above is the first incarnation of Holy Trinity Catholic Church, which was at 34 Maple Street and was dedicated on April 19, 1868. The current church stands in the same location and was built in 1932.

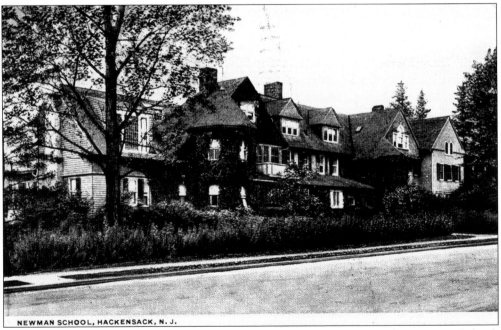

NEWMAN SCHOOL, HACKENSACK, N. J.

Considered one of the best preparatory schools for boys on the East Coast, the Newman School, shown here in 1921, was located on the corner of Polify Road and Essex Street. Among the school's more noteworthy alumni was F. Scott Fitzgerald, who was sent to the school from his home in Minnesota.

In 1797, the first post office was established in Hackensack. In 1841, Henry Banta became postmaster, and it was from his family that the government purchased the land on the corner of Banta Place and State Street, the site of the present post office building.

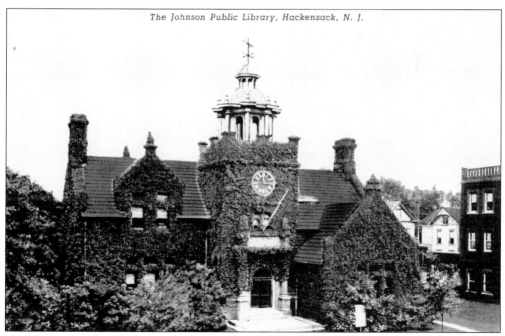

The Johnson Public Library, Hackensack, N. J.

The Hackensack Public Library has had a number of different looks over the years. While this impressive landmark is basically unchanged, the beautiful green ivy clinging to its stonework gives the building a completely different look. In 1967, an extensive enlargement of the facility was completed, including a new main entrance in the rear of the building on Moore Street.

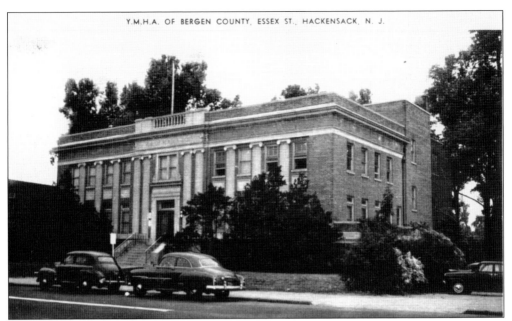

In 1917, generations of nonprofit, voluntary groups joined together, helping another generation of Jewish immigrants assimilate into American society. In 1923, prominent Jewish citizens met to raise funds for a YM-YWHA (Young Men's, Young Women's Hebrew Association) in Hackensack. Chartered in 1924, completed in 1928, and dedicated in 1929, it serviced the community for more than 60 years. Since 1987, this specific building no longer houses the YM-YWHA, but it is now known as the YJCC of Bergen County and is located in Washington Township.

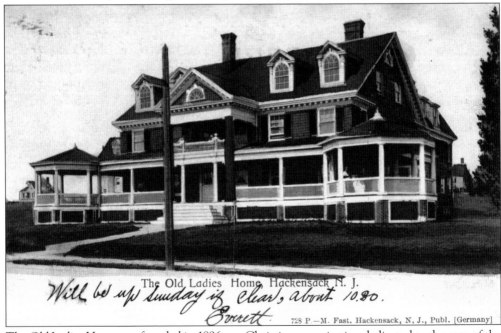

Will be up Sunday if clear, about 10.30.
Everett

The Old Ladies Home, Hackensack N. J.
728 P.—M. Fast, Hackensack, N. J., Publ. [Germany]

The Old Ladies Home was founded in 1896 as a Christian organization dedicated to the care of the area's elderly women. The need for larger accommodations led to the organization's move in 1902 to the building pictured above. It was located on Passaic Street and was razed in the early 1990s.

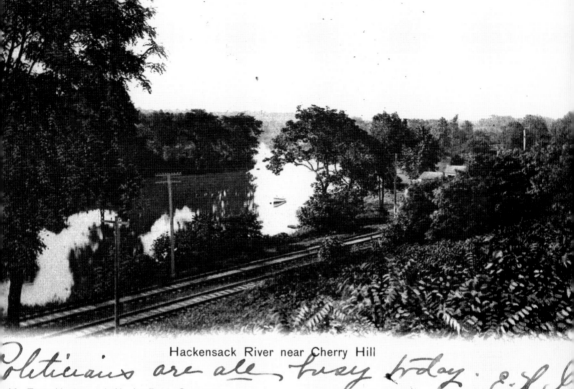

Hackensack River near Cherry Hill

Politicians are all busy today. E. L. J

M. Fast. Hackensack N. J., Publ. Germany.

Hackensack, like many cities across the United States, has particular sections of its city with an illustrative name. Fairmount is one such area located in the northwest end of Hackensack. Until about 1890, this part of Hackensack, as well as the southern portion of River Edge, was known as Cherry Hill. For a few brief years before that, the area was known as Zingsem because G. N. Zingsem, the architect of the renowned Fairmount Park in Philadelphia, owned most of the region. A good portion of the Fairmount area was used for growing trees and shrubs. They were shipped by Zingsem via railroad and planted in the Philadelphia park. In time, this area of Hackensack took on the park's name. Today many streets are named after those trees that were grown, such as Elm, Poplar, Cedar, and Catalpa. Probably the most notable grand hotel in Hackensack was the Fairmount Hotel, which operated from about 1870 to the later part of the 19th century, regrettably destroyed by fire. Until about 1925, more than half of today's Fairmount was farmland, but the area also included Campbell's Wall Paper and Krone's School Supply Factories, about six gas stations, a few general stores, a school, a church, and many large old homes and estates.

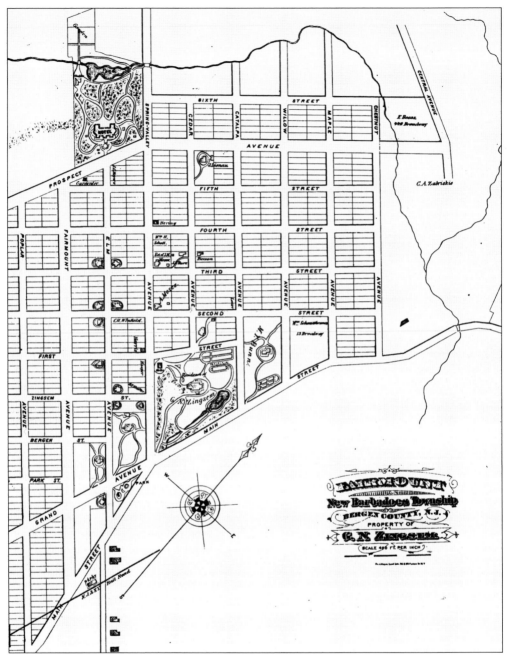

Shown here is one of the early maps of the area and designated as the "Property of G. N. Zingsem." The upper left-hand corner of the map shows the location of the very beautiful Fairmount Hotel, garden, and grounds. As Grand Avenue turned into Main Street at Spring Valley Avenue, the huge estate of G. N. Zingsem can be seen with its pond, gardens, stables and drives leading to the home.

96

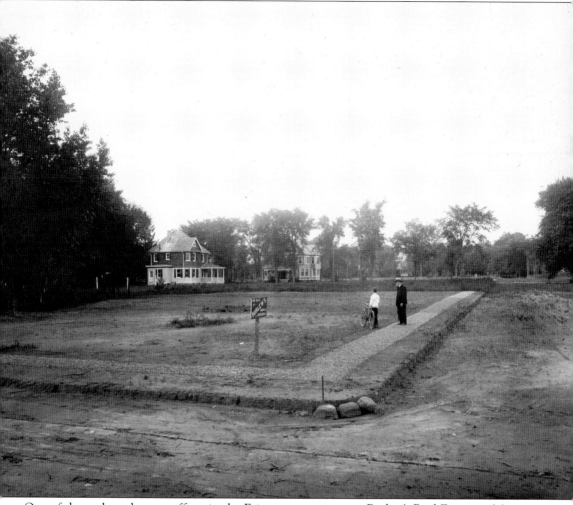

One of the early real estate offices in the Fairmount section was Burlew's Real Estate on Main Street and Johnson Avenue. This early photograph of a lot being offered by Burlew's Realty shows the northeast corner of Fairmount Avenue and Krone Place. Today this corner is part of a typical Fairmount neighborhood with streets lined with beautiful trees and a mix of contemporary and vintage homes with well manicured lawns in a quiet suburban setting.

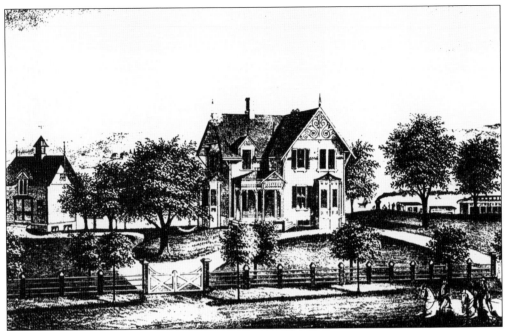

Shown above is a *c.* 1876 etching depicting the beautiful summer residence of George Miller in the north Hackensack or Fairmount area. The train in the background may have been an embellishment by the artist. This section of Hackensack had its share of exclusive homes and estates. Featuring a lake and many ponds, it made a beautiful setting for the future suburban Fairmount neighborhood.

The Children's Home Society was a national organization that sought to place homeless and orphaned children in good homes. The Hackensack branch of the society was organized on March 23, 1895. Located on Essex Street, just east of the railroad station, the Bergen County Children's Home was the former residence of J. A. Clairmounte. By 1902, the society showed that although only a few years old it had successfully handled 574 cases, many of which were children placed in good homes.

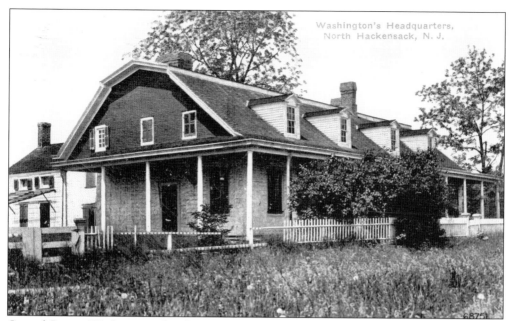

One of George Washington's headquarters, later to be known as the Von Steuben House, was built in 1752 in north Hackensack, now River Edge. This home was used by General Washington and his staff in 1780. Shown above in this *c.* 1911 photograph, the home is one of the area's most historic sites. Below is a 1930 photograph of the home, which later became the headquarters of the Bergen County Historical Society. Today the building is in need of repair and all of the society's books, maps, and documents have been moved to the Johnson Library.

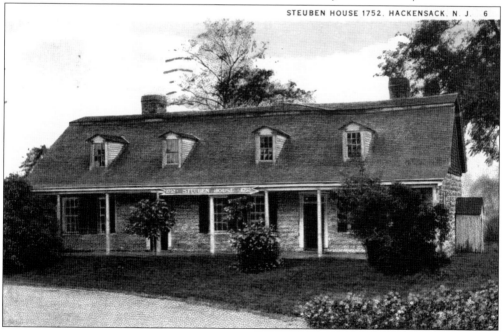

STEUBEN HOUSE 1752, HACKENSACK, N. J. 6

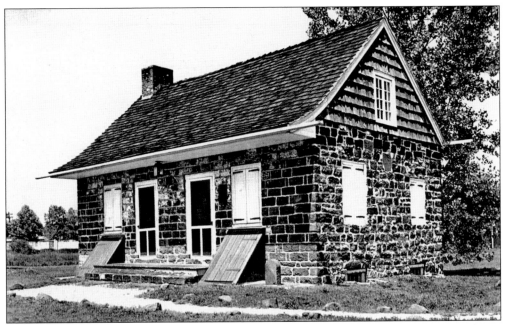

Part of the Von Steuben museum complex, located along the river in what is now River Edge, is the Demarest House, built in 1678, as well as a museum. This building, which is adjacent to the Von Steuben House, was moved in 1956 to this site, stone by stone, from New Milford.

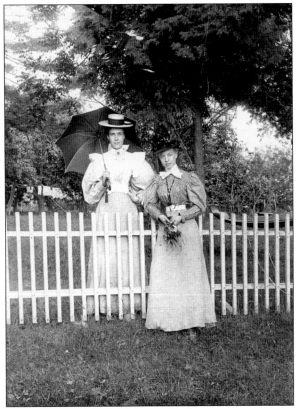

Posing by the side-yard fence of her home in the Fairmount section of Hackensack is Isabelle Duncan. She is seen in this photograph with her friend Edith Halleck, who is holding some newly clipped flowers. Seemingly a summer photograph from around 1900, the laundry on the clothesline and a hammock can be seen in the background. Both women appear comfortably cool despite their lengthy skirts, long-sleeved blouses, and fanciful hats. Perhaps the umbrella and the shade of the large pine tree seen in the photograph offered some cool relief, but one wonders how ladies went about their daily tasks, visiting with friends and the like, with those warm-looking yet stylish clothes of the era.

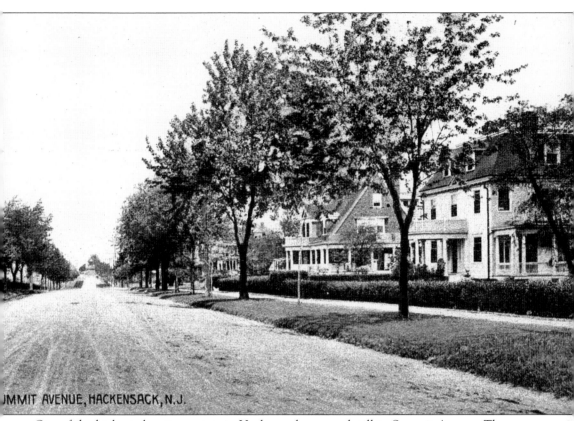

JMMIT AVENUE, HACKENSACK, N.J.

One of the highest elevation points in Hackensack was, and still is, Summit Avenue. The area known as the Heights was a quiet residential road. Summit Avenue was lined with large and fashionable homes, as shown in the photograph above. The unpaved roads without cement curbs were standard at the dawn of the 20th century. Many of the beautiful homes on Summit Avenue still exist today as part of Hackensack's more affluent neighborhoods, although with the proximity to Hackensack University Medical Center, many homes have been converted to doctor's offices. Running parallel to Summit, one block to the east, is Prospect Avenue. Like Summit Avenue, it was the location of many beautiful and sprawling estates, some of which still exist today, but with Hackensack's booming residential appeal, many high-rise condos have dwarfed the remaining luxurious homes.

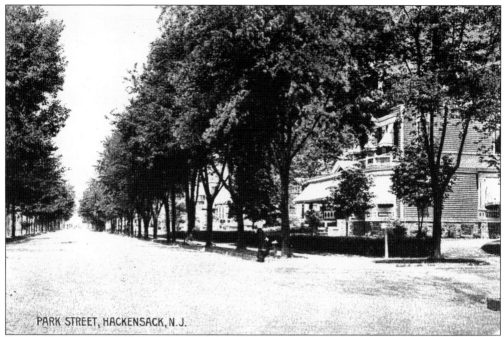

PARK STREET, HACKENSACK, N.J.

This *c.* 1907 view of Park Street, with its beautiful homes and well manicured lawns, completed the look of this quiet residential street. Today much is the same on this street, which is only a few blocks west of busy Main Street.

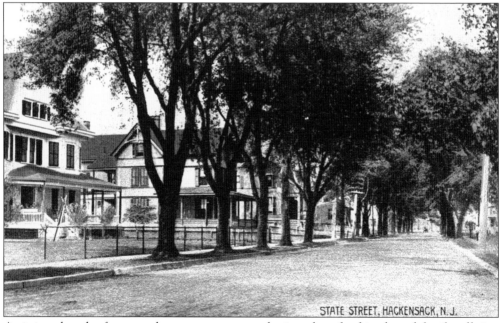

STATE STREET, HACKENSACK, N.J.

As it is today, the front porch was a common gathering place for friends and family offering a welcome respite at the end of a busy day. The homes shown here around 1907, lining State Street, were typical dwellings found in Hackensack.

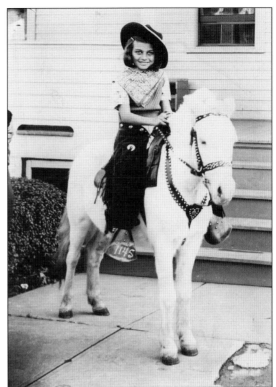

In the 1920s, it was a standing order for the birthday boy or girl to have their picture taken with a pony. There were many such ponies in Hackensack that traveled with their photographer around the city. The picture was usually taken in front of the family home. Gloria and Ted were two such lucky celebrants on their special day.

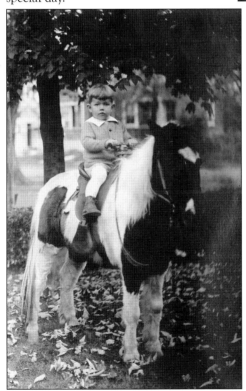

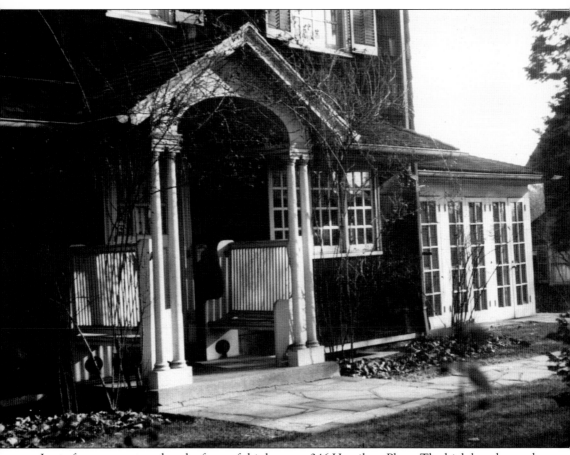

Late afternoon sun catches the front of this home at 346 Hamilton Place. The high benches and the luxury of having an adjoining porch with French doors was the look of several homes in the 1920s. Both signified a "welcome and sit down" feeling to any friend who rang the doorbell.

Having a front porch was a welcoming and relaxing addition to this home at 33 Clinton Place. It invited one to sit and have a glass of lemonade on a hot summer's day or watch the fireflies as dusk presented itself. A porch enticed friends to stop by to sit on the front stoop and maybe sport a quick game of jacks. If all this was a bit too bustling for a family member like Alice P. Liddle, the back steps offered the opportunity to take a break, put down the mop, and catch up with a favorite book. Where this house stood is now the parking lot of Holy Trinity Church.

Pictured above is little Dorothy Liddle, who happened to sneeze as this photograph was taken in front of her home on Maple Avenue after stepping down from the porch. Dressed in a tailored coat and hat, she may have been ready to go to a party or someplace "special" the day the photograph was taken. This avenue was quite wide in the early years of the 20th century. The homes seen in the background would eventually be torn down to make room for the rebuilding of Holy Trinity Church.

Thomas Purdy Smith was born in Bergen County around 1875. Here he stands sporting his straw hat while standing in front of his home, in 1921, at 871 Summit Avenue. Smith was known to be very proud of living in Hackensack. The parents of nine children, Smith and his wife Tillie, grew much of the family's food on a small farm in back of the family home. He also delivered milk in a horse-drawn wagon throughout Hackensack.

On appearance, this seemingly distinguished and well-groomed young boy, in his late-1920s attire, makes one wonder how soon the book would be placed down along with the teddy, only to find him with dirt scuffed knees and disheveled hair from having a grand time playing in the backyards of the neighborhood children.

Having a little rowboat or a canoe to take down to the Hackensack River in the early 20th century was a great escape for anyone, young or old. Grabbing a fishing pole and a box of bait was all that was required to paddle to that special part of the riverbank where one knew the catching was good.

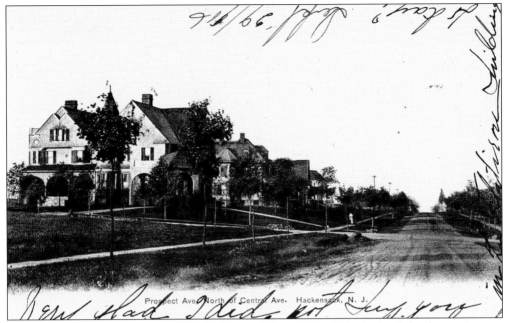

In 1906, Prospect Avenue was a simple dirt road but still had the look of the future. Luxury homes lined the avenue that it would later become. Today many expensive, high-rise condos have replaced those grand old homes on this well-known, busy street.

By 1922, George and Adeline Sellarole had been married for just two years. The couple would go on to have five children, all of whom graduated from Hackensack High School and would remain in the area to proudly raise another generation.

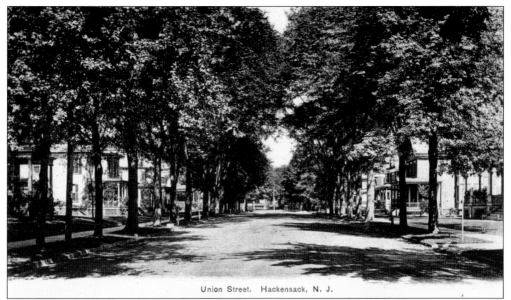

Union Street. Hackensack, N. J.

Union Street with its beautiful trees offered a shady retreat on a hot summer's day in 1908. These quiet neighborhoods of Hackensack were part of the growing community in the early part of the 20th century.

In the baby boomer age, taking pictures seemed appropriate for any occasion even if not one of particular importance. These two young Hackensack girls in the mid-1950s are perhaps dressed for Easter Sunday, a neighborhood birthday party, or a festive family outing. Probably yearning to play outdoors, their desire to change to a set of play clothes would transpire only when the occasion was over.

River Street, North, Hackensack, N. J.

It is difficult to imagine this heavily traveled road, as it is known today, was once a lazy, tree-lined street. This image of River Street in 1905, looking north, connects Route 46 and Route 4 on Hackensack's eastern border.

Suited up and ready to go for a swim, this family may have been heading off to the Elmside pool or maybe to Green Pond in Morris County, which for those living in Hackensack in the 1920s were favorite spots to go for a dip in the water and cool off.

The Smith family of Hackensack, shown here in 1924, lived on Summit Avenue. All nine children grew up in Hackensack and stayed in the area. One sister went on to own a diner on Court Street, a brother became one of the first projectionists at the then newly built Fox Theater on Main Street, and another sister owned and managed the Fairmount Delicatessen.

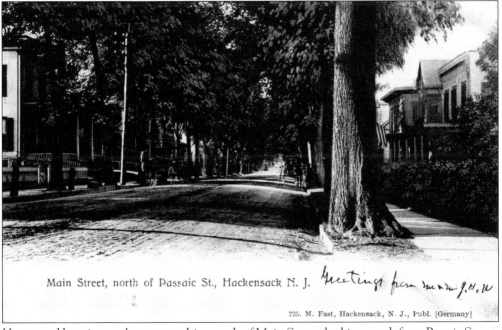

Main Street, north of Passaic St., Hackensack N. J. Greetings from ...

725. M. Fast, Hackensack, N. J., Publ. [Germany]

Horses and buggies can be seen on this stretch of Main Street, looking north from Passaic Street, in 1907. Today this part of busy Main Street is lined with shops, banks, and restaurants.

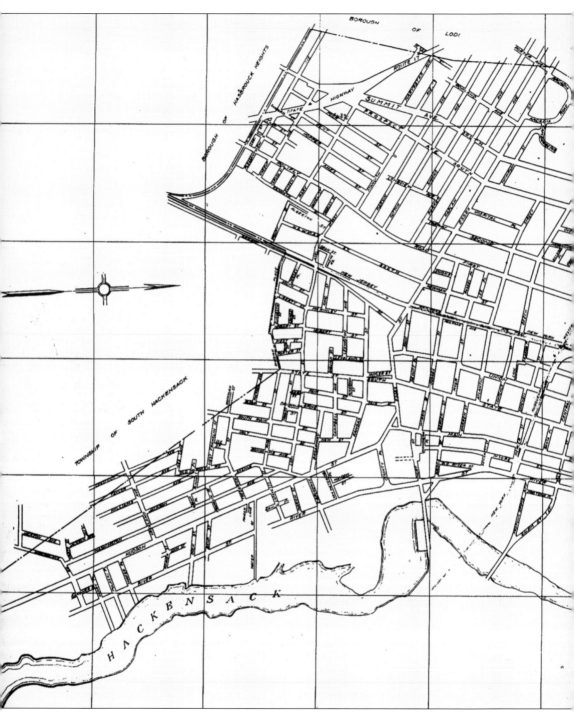

This street map of Hackensack from 1956 shows little change from today. Morris Street, a one-block stretch, no longer exists and is now a continuation of Sussex Street. The Hackensack River bordering the eastern edge of the city shows exactly why Hackensack has been the perfect

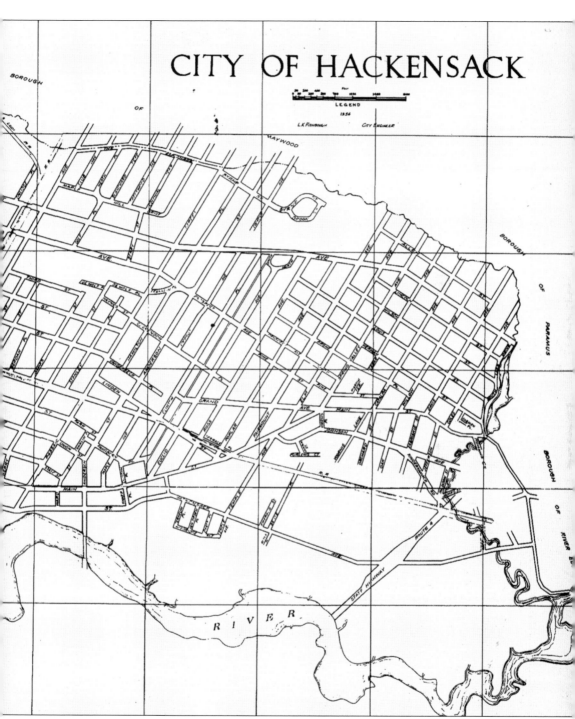

location for business and commerce to flourish. Today Hackensack is bordered by major highways on all of its boundaries.

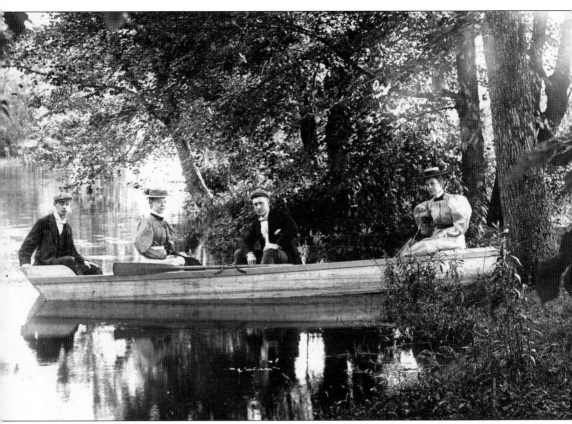

On July 30, 1897, these two couples, seemingly overdressed for boating compared to today's standards, rest their rowboat against the banks of the Hackensack River, perhaps to picnic or relax under the spotted shade of the many trees that lined both sides of it. The river appears to be quite still at the time this photograph was taken, and for the rower, the most opportune time to take a well-rewarded break. If one knew how the tides were running on such a specific day, rowing north several miles and then gliding south back to Hackensack would be nearly effortless, bringing an end to a perfect day on the water.

Backyard pools were almost unheard of in the 1920s for those living in an average Hackensack neighborhood. This group of youngsters on Ross Avenue made their own afternoon fun with a spray from the garden hose. Most assuredly, this was a perfect substitute for a swim in a pool on a hot summer's day.

The Boy Scouts of America was incorporated on February 8, 1910, and soon after came to Hackensack. Since those early days, the city has had a long history of having among its residents many Boy and Girls Scouts. Shown here in the mid-1950s are Cub Scout Pack 211 members, proudly showing their merit badges to the Fairmount School PTA.

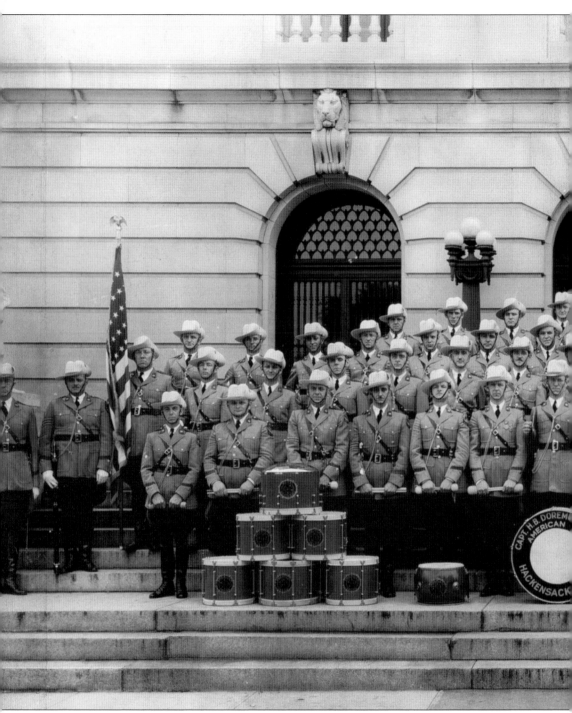

In July 1919, 15 ex-servicemen met to discuss a formal application for chartering a local American Legion post in Hackensack. Unfortunately, Capt. Harry B. Doremus, who led the local company, was killed in action in the famous Argonne-Meuse offensive in 1918, and was the only man whose name was considered for the post. A charter was granted and soon after designated Legion Post No. 55 in 1920. A home was used as a clubhouse at Bridge and Mercer Streets. A

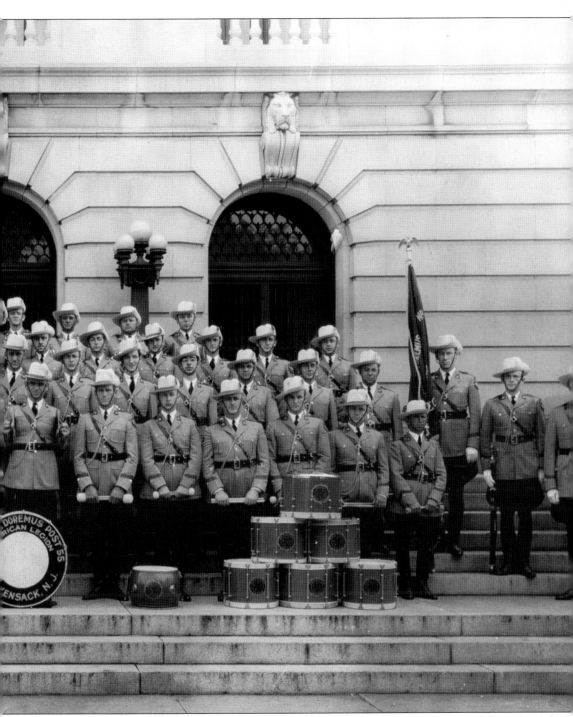

new home was later built in 1933 and is still standing at American Legion Drive and Second Street. For many years, the post sponsored a senior drum and bugle corps and color guard, which took national championships in Chicago in 1939 and in New York in 1947. Shown here are the complete Capt. H. B. Doremus Post No. 55 Drum and Bugle Corps and Color Guard on the steps of the county courthouse in Hackensack.

Going off to war for the nation during World War II was for many not only their duty but also showed the world that the United States was made of "the right stuff." Women participated in many ways in the military effort. They could support it stateside by working in factories making war supplies. They also could enlist as a U.S. Navy WAVE (Women Accepted for Volunteer Emergency Service) or a U.S. Army WAC (Women's Army Corps). Among the many other possible services to aid the war effort was by being a military nurse boarding the ships that embarked for Europe to bring home America's wounded. Lt. jg Harry G. Gooding Jr., of the U.S. Navy (a Hackensack-born-and-raised resident who served in the Pacific) and 2nd Lt. Marion H. Vreeland, a U.S. Army nurse (who brought the wounded home), met during wartime and married in 1945. Within a few years, they moved to Hackensack and to this day reside here.

Like so many young men in 1916, Alfred Schoonmaker, brother of Steven Townsend (Ted) Schoonmaker, was proud to serve his country in World War I. Handsomely dressed in military attire, photographs such as the one pictured would be taken and made as postcards to be mailed home to friends and family.

Capt. Steven Townsend (Ted) Schoonmaker, stationed at the time in France, sent home this postcard dated September 22, 1918, with the tents that were his barracks positioned behind him. Unfortunately, 34 days later he would be killed in battle, 17 days before the end of World War I, never to see Hackensack again. In addition to living in Hackensack, Schoonmaker spent part of his growing years in neighboring Teaneck, which dedicated Schoonmaker Road and Post 1429, Veterans of Foreign Wars of the United States, in his honor.

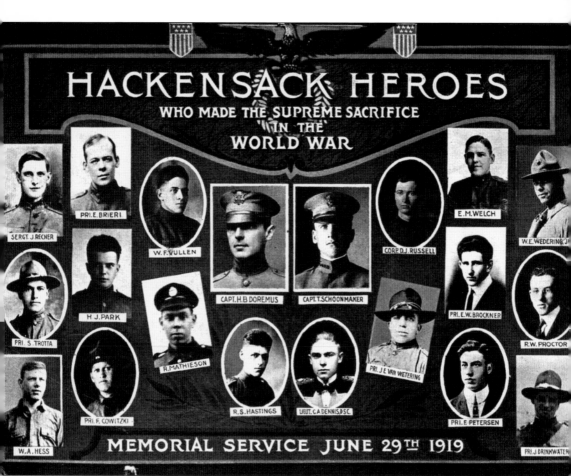

It was the 11th hour of the 11th day of the 11th month in 1918, when World War I—"the Great War" or "the War to End All Wars"—ended. Hackensack, like so many communities in the United States, had sent its boys off to war, with many never to return. One June 29, 1919, a memorial service was held in Hackensack to honor Hackensack heroes who made the supreme sacrifice in the World War (at the time the term World War I was not used). This piece commemorates the honor roll of those who did not come back between 1917 and 1919 and includes Capt. H. B. Doremus and Capt. Stephen Townsend (Ted) Schoonmaker.

Postcards depicting the monument to Brig. Gen. Enoch Poor were popular during the early part of the 20th century. This c. 1907 postcard shows the old courthouse as a backdrop for the statue. In the more modern-day photograph, the monument faces the courthouse; apparently the statue was rotated over the years. Today Brigadier General Poor still stands guard over Hackensack.

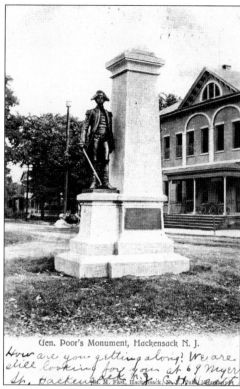

Gen. Poor's Monument, Hackensack N. J.

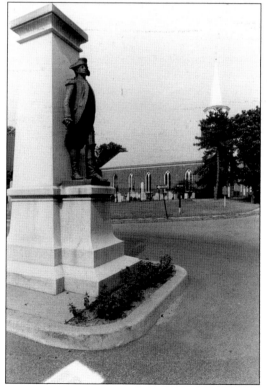

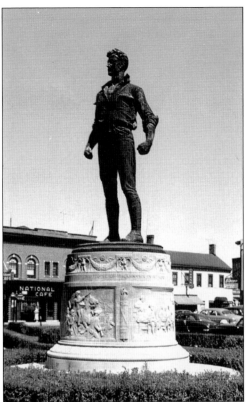

One of Hackensack's most prominent statues is the World's War Memorial. This imposing figure of strength stands in the center of the Green. The inscription circling the base reads "Erected in 1924 by the people of Hackensack in memory of its soldiers and sailors who fought in the wars of the United States of America." This statue, along with the cannon depicted below, is part of the collective memorial known as the Soldiers and Sailors Monument.

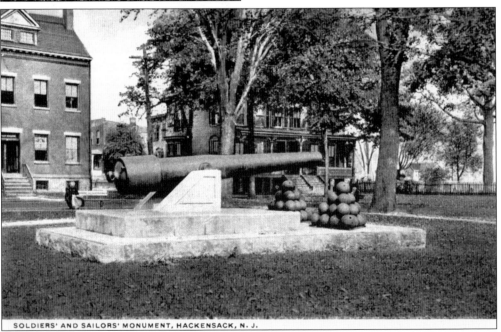

SOLDIERS' AND SAILORS' MONUMENT, HACKENSACK, N. J.

The Soldiers and Sailors Monument, shown on the Green around 1918, still stands today. The only thing missing are the cannon balls, which were melted down and used for the war effort during World War II.

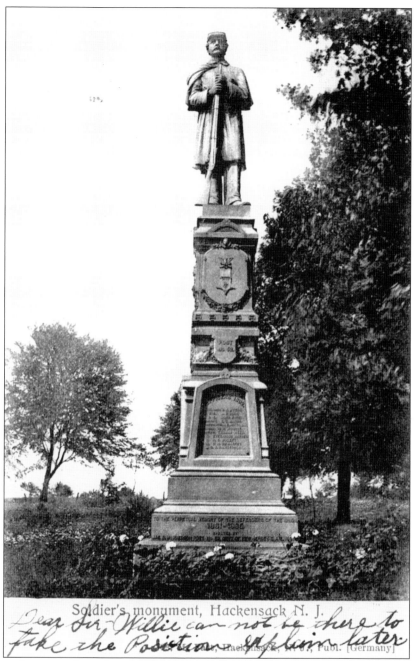

Soldier's monument, Hackensack N. J.

Dear Sir, Willie can not be there to take the Position, Hackensack, N. J., Publ. [Germany]

Americans have a rich tradition of honoring those who have sacrificed themselves in order that all might enjoy the liberties the people have come to cherish. The residents of Hackensack have played an important part in every major conflict in which the country has been a part. Many have paid the ultimate price for freedom, and the residents of Hackensack have a long standing practice of erecting monuments to the memory of those who served. In 1898, the Civil War Soldiers Monument was erected in Hackensack. It is located in the Hackensack Cemetery on Hackensack Avenue near Route 4. The monument honors the contributions made by Hackensack citizens during the nation's bloodiest conflict.

DEDICATION CEREMONY
SUBMARINE MEMORIAL

U.S.S. LING
AGSS-297

Sunday, October 14, 1973 1:00 p.m.

Borg Park,

150 River Street, Hackensack, N.J.

To those that contributed their time and energies to make the Submarine Memorial a reality, the opening ceremony was a proud day for all personally involved in the City of Hackensack.

The 312-foot-long USS *Ling-SS 297* was dedicated and opened to the public on October 14, 1973. Resting on the Hackensack River, it is a memorial to the 3,505 men who were lost on 52 submarines during World War II. With a yearly property lease of $1, graciously donated by Donald and Malcolm Borg of the *Record*, the submarine is a fitting reminder of the men whose sacrifice helped preserve the nation's freedom. Harry Gooding Jr., along with Herb Georgius and Fred Johnson (pictured below, from left to right), were among the original small handful of World War II veterans that formed the Submarine Memorial Association (SMA). With the help of the U.S. Army Corp of Engineers, the Alpine Geophysical Associates of Norwood, B. Franklin Reinauer, elected officials, congressional representatives, businesses, and ordinary citizens, together they succeeded in creating the memorial as it is today.

One of Hackensack's most notable citizens and the most eminent educator in the history of the Hackensack school system was Dr. Nelson Haas. His history of service includes being the principal of the Washington Institute in 1878 and later at Union Street School. In 1894, it is documented that he became the first supervising principal of the school system in the village of Hackensack. With the newly built high school, which opened Thanksgiving Day 1897, Dr. Haas was given the job as its first principal. From 1897 to 1905, he had the additional honor of being Hackensack's first superintendent of schools. Under his tutelage, he helped to graduate no less than 90 students who later became school teachers. Of the scholarships available at that time, his students dominated the awards with many receiving free scholarships to the United States Military Academy at West Point and the United States Naval Academy at Annapolis.

Dr. Nelson Haas died in 1905 and was laid to rest in the Hackensack Cemetery. A large monument marking the spot stands prominently in the very first section of this large historic cemetery. His monument reads: "In memoriam Nelson Haas, Ph.D., Educator. Born 1838 Died 1905, erected by The Citizens of Hackensack."

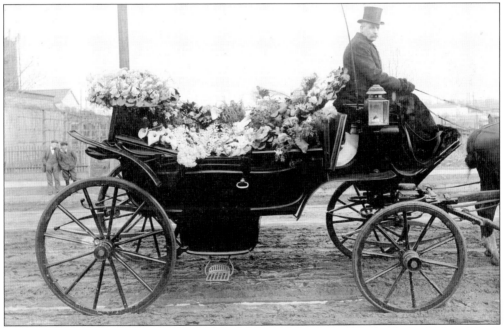

As one of Hackensack's most distinguished citizens at the time of his death, Dr. Nelson Haas's funeral was an elaborate event. The accomplishments of Dr. Haas in the field of education drew throngs of mourners to his memorial service. Dr. Haas's legacy as one of the founding fathers of the Hackensack school system lives on to this day, with the tradition of providing a quality education to all of the city's children; those of the past, present, and in the future.

ACROSS AMERICA, PEOPLE ARE DISCOVERING SOMETHING WONDERFUL. THEIR HERITAGE.

Arcadia Publishing is the leading local history publisher in the United States. With more than 3,000 titles in print and hundreds of new titles released every year, Arcadia has extensive specialized experience chronicling the history of communities and celebrating America's hidden stories, bringing to life the people, places, and events from the past. To discover the history of other communities across the nation, please visit:

www.arcadiapublishing.com

Customized search tools allow you to find regional history books about the town where you grew up, the cities where your friends and family live, the town where your parents met, or even that retirement spot you've been dreaming about.